ICONS

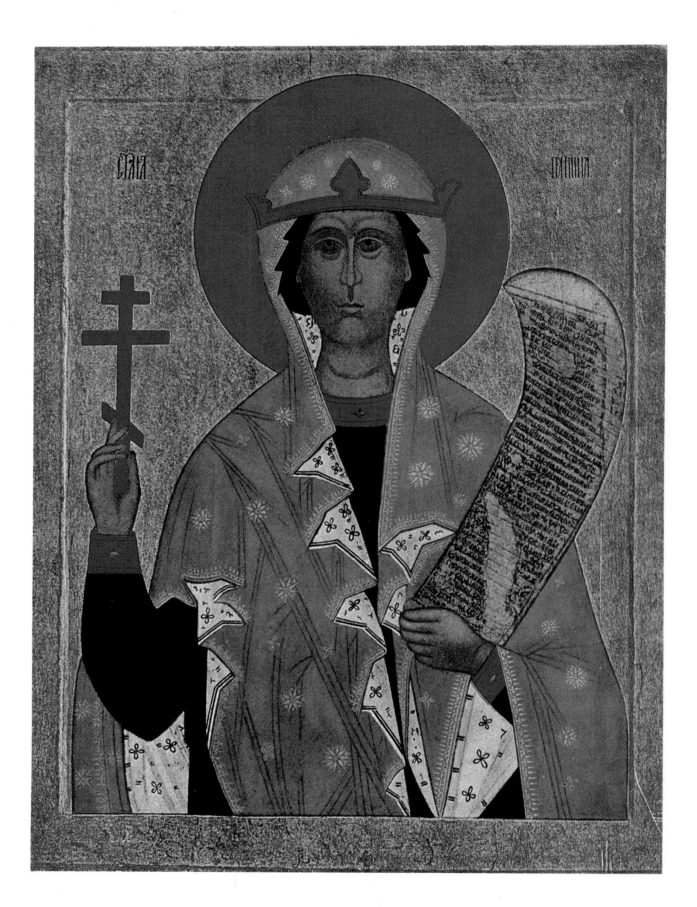

ICONS

INTRODUCED BY
T. TALBOT RICE

WELLFLEET
PRESS

FRONTISPIECE

Icon of St Paraskevi-Piatnitsa (Friday)

Late fifteenth, early sixteenth century. School of Novgorod, possibly from Pskov. Formerly in the Ostroukhov collection.

St Paraskevi was greatly venerated, first in the Balkans, then in the district of Novgorod, where both she and St Anastasia were considered the patronesses of commerce, whether conducted on a large scale by the wealthy merchants or in the local markets by the peasants. Two saints of the name are known to history, the one being martyred under Antonine, the other under Diocletian, but in Orthodox iconography both are fused in the one Paraskevi. She is worshipped on Friday, the fifth day of the week (Piatnitsa), the very day which had been devoted from very early times, more especially in Italy and Sicily, and perhaps most of all in Venice and Candia, to the honouring of holy women and virgins. St Piatnitsa, worshipped by the Slavs, had lived the completely isolated life of a hermit. In Russia she was venerated on October 28th, and was regarded there as the patroness of all women. In iconography she is often shown with her head and shoulders covered by the stole associated with an order of deaconesses; a variant of it appears on the present icon.

This painting is in the transitional Novgorodian style, but the green background and the absence of highlights in the face, where the modelling is obtained by the use of darker shadows and underlining, suggest an artist from Pskov.

Icons
was originally published by
Batchworth Press, London

This edition published by
The Wellfleet Press
a division of Book Sales, Inc.
110 Enterprise Avenue
Secaucus, New Jersey 07094

First published 1990 by Studio Editions Ltd.
Princess House, 50 Eastcastle Street
London W1N 7AP, England

ISBN 1-55521-632-3

Printed and bound in Hong Kong

CONTENTS

LIST OF PLATES

INTRODUCTION

In 1844 a son was born to one of the principal peasant families living in a quiet village in the district of Kursk in Russia. Paul Kondakov, the child's father, was a serf, but he was also factor to Prince Trubetskoy, to whom the village belonged. The boy was christened Nikodim, and there was nothing to distinguish his early years from those of countless other peasant boys in the neighbourhood, nothing to suggest that he was to become one of the foremost scholars of his day, an authority with a world-wide reputation. However, he was not to spend many years in his native village, for his father's services were rewarded with the gift of personal freedom, the Kondakovs moved to Moscow, and the boy was sent to school. At the age of seventeen he was already an undergraduate at Moscow University, studying history and philosophy. Six years later he was in a position to set out on the first of the numerous journeys which, in the course of the next thirty years or so, were to take him all over European Russia, western Europe, the Balkans and the Near and Middle East, to study the art and archaeology of these lands. In 1870 he was appointed to the Chair of Fine Arts at Novorossisk University. From then onwards, apart from his many duties as a teacher, he was able to devote himself to the study of Russian and Byzantine mediaeval art and archaeology. He was quick in publishing the results of his researches, and each new work proved illuminating and immensely stimulating. Honours were heaped upon him. They included election to the Academy, but in 1909 he was particularly gratified at being appointed chairman of a committee formed to encourage the revival along traditional lines of the dying art of icon painting.

The outbreak of the revolution found Kondakov in the Crimea. Soon after he moved to Odessa, where he completed his great work on the Russian icon, but in 1920 he left for Varna. It was there that, two years later, he received an invitation to settle in Prague. He was delighted by the offer, accepted, and lived in Prague until his death in 1925, lecturing regularly on various aspects of the art of the Middle Ages in central Europe. On his eightieth birthday it was decided to celebrate the event by undertaking the publication of his work on The Russian Icon. Kondakov did not live to see the task accomplished, for the book did not appear till 1931, but the last year of his life saw the realisation of a long-cherished dream – the holding at Bucharest of the first Congress of Byzantine Studies ever organised in western Europe. Kondakov was able to take part in the proceedings. The Congress now meets at regular intervals in various European centres of learning. Its creation proved a fitting close to a life devoted to the establishment and development of Byzantine studies.

The year after Kondakov's death saw the appearance of *Byzantion* – a learned journal published in western Europe to deal exclusively with Byzantine matters. The first volume was dedicated to Kondakov's memory. then, in 1927, the Seminarium Kondakovianum was founded in Prague in the scholar's honour. Both tributes were well deserved, for it was largely as a result of Kondakov's efforts and enthusiasm that Byzantine art eventually received general recognition, and that the masterpieces of this school have been reinstated to their rightful place beside those of the world's other great schools of art. Kondakov's main efforts were principally directed at awakening wide interest in the marvellous religious paintings of mediaeval Russia. By devoting himself to the assiduous study of the surviving paintings he was able to trace the broad lines of their development, to distinguish the styles of the principal schools, and to arrive at an approximate dating of most of the major works which were available to him. This was an arduous and meticulous task, for all the paintings followed the traditional lines of early Christian iconography, none of the early works was signed, and few records survived to guide him in his enquiries. Even so, Kondakov almost invariably reached the correct conclusions, and although the large-scale cleaning and restoration work undertaken in the USSR since the revolution has brought to light much new information which has naturally affected some of Kondakov's dating and added many new details to his outline, yet, taken by and large, it is astonishing how few of the fundamental views or attributions expressed in his truly monumental works need amending.

In Russia, interest in both Byzantine and religious Russian art became fairly widespread as early as the eighteen-thirties, and it was at about this time that several wealthy merchants started to collect icons for their artistic as distinct from their religious significance. Scientific societies were formed which fostered this interest, and in consequence the price of old icons rose considerably. Tempted by this new market, an enterprising photographer of the eighteen-eighties persuaded the religious authorities of the Caucasus, where many ancient monasteries survived, to allow him to replace the worn and dirty icons preserved in their churches by nice, shiny new ones. He succeeded in this way in acquiring several early works which he then sold for prices ranging from £750 to £1000 each. The authorities in St. Petersburg soon heard of his activities and promptly put a stop to them, but they had had a stimulating effect both on dealers and antiquarians, and many famous collections such as the Ostroukhov and Riabushinsky date from that time. In 1913 icons formed an important section of the exhibition of early Russian art organised in Moscow in connection with the celebrations marking the tercentenary of the Romanovs' rule.

'Icon' is a Greek word meaning 'image', and, just as the Greek Orthodox Church thinks of itself as the heavenly kingdom's reflection upon earth, so does it regard icons as the images of the personages and scenes represented on them. Icons are indeed the sacred religious pictures of the Greek Orthodox Church, and although in later times some were made of metal, the bulk consist of paintings upon wood. The form originated from the tomb portraits of ancient Egypt. The Byzantines perfected the technique and evolved their iconography, transforming the old medium into something wholly Christian and entirely their own. The Russians carried the art rather further, giving it a national complexion.

The process of preparing a board for the painting of an icon was fairly complicated. To begin with the surface of the panel had to be smoothed and, if considered necessary, its back had to be strengthened by the insertion of wedges into specially cut slats. Then the front of the board had to be covered with a layer of gesso, which to some extent corresponded to the plaster surface of a wall. Fairly often this was covered by a layer of canvas, well rubbed into the gesso and itself again overlaid by a thin layer of gesso. When the gesso had hardened, it had to be polished to form a smooth, shiny surface on which the outlines of the pictures were sketched in, red paint being often used for the purpose in Russia. These outlines kept very close to tradition as laid down in a body of tracings called 'Podliniki' or 'Authorised Versions', assembled into manuals for the use of the painters. Next the background was applied, golf leaf being generally chosen, though the Russians sometimes preferred silver or red, whilst at Novgorod painters were particularly fond of a white ground, and at Pskov of a green one. Only when the background had dried could the painter devote himself to the execution of the actual scene, doing so with colours which he diluted with yolk of egg to give them the necessary brilliance and opacity.

To begin with icons were primarily produced for use in churches and for carrying in processions, the latter being generally painted on both sides of the board. These early icons were generally fairly large in size, but with the introduction of the elaborate iconostasis – which was almost certainly a Russian innovation dating from the fourteenth century – they tended to become smaller. The iconostasis served both as a screen separating the body of the church from the apses in which the altar stood and also, as its name implies, as a stand for icons. From the first the place of an icon on an iconostasis was exactly defined, and the icons in the main or first row were always rather larger than the others. In Moscow, from the fifteenth century onwards, a demand arose for smaller icons, for these were better suited for use in the small private chapels which were being built in large numbers throughout the capital. The growing prosperity of the Muscovites also rendered the personal ownership of icons possible, and it became usual then to place an icon in the far right-hand corner of each room, as well as at the head of each bed in the house. The custom of studding an especially beloved icon with jewels arose in the fourteenth century and was followed soon after by the introduction of metal frames, or of metal casings covering either all but the faces and hands of the figures or only such details as their halos.

Christian art was introduced to Russia at a relatively late date, when already fully developed, for it was only in 988 that Vladimir, Great Prince of Kiev, adopted the Greek Orthodox form of Christianity as the official religion of his principality. Vladimir ordered the destruction of all pagan objects of worship, and the art of Constantinople then also became that of Kiev. Vladimir drew some of the prelates and craftsmen he now required from Bulgaria, but the bulk came to him from Byzantium, and as he was in a hurry to provide his principality with numerous churches of sufficient magnificence to win over his people, Russian craftsmen were appointed to assist the Byzantine masters in carrying out the ruler's wishes. In Kiev great churches were built with amazing speed and adorned with sumptuous mosaics and paintings, but Vladimir had once again to turn to Byzantium for the vestments and fittings needed to complete them.

Icons were among the first of the religious objects which Vladimir and his immediate followers imported from Byzantium, but so far, notwithstanding the admirable work carried out in post-revolutionary Russia by the State Restoration Workshops, no panels dating from the tenth century have as yet been discovered there. The earliest examples brought to light belong to the eleventh century, and these, with but rare exceptions, are the works of Byzantine and not of Russian artists. However, some of twelfth- and thirteenth-century icons belonging to the schools of Novgorod and of Vladimir Suzdal have been uncovered by present-day Russian restorers. Although the Byzantine elements prevail in the majority of these early paintings, the presence of markedly Russian characteristics is already clearly apparent. Thus, the faces painted by the Russians have a somewhat more natural oval and a less stern expression than the Greek ones, the bodies are stockier and less elegant, with a flatter look about them, owing to the absence of the modelling which is so characteristic a feature of Byzantine art. On the other hand their outlines are more definite, more linear and more succinct, and the impact they make is sharper owing to the elimination of all unessential detail.

The twelfth- and thirteenth-century icons of the school of Vladimir Suzdal were for the most part concealed from Kondakov by later overpaintings, but by basing his opinion on somewhat later icons of this school he was able correctly to determine the importance of its influence on the development of later Muscovite painting. He was equally quick at appreciating the glory of Novgorodian painting, and here a mass of material lay ready for him to study.

Novgorod had had a fortunate history, for of all the great towns of mediaeval Russia it alone had been spared the Mongol invasion of 1244 and the two centuries of Asiatic occupation which followed. Independent, autonomous and secure, Novgorod was able to develop normally, establishing profitable commercial relations with western and northern Europe, and rapidly evolving into a prosperous and flourishing merchant republic. Artists had first come to Novgorod with Christianity, and by the twelfth century their number had grown very considerably, but when the Mongols gained political control over the rest of the country, they flocked to Novgorod. Only in this unoccupied corner of their land could their art develop free and untrammelled and thus, almost by force of circumstance, Novgorod served throughout the next three centuries as the country's cultural centre, playing much the same part in the history of Russian art as does Tuscany in that of Italy.

To begin with, the Novgorodian artists had looked to Byzantium for guidance, just as the artists of Kiev had done, but in the same way as the Kievian artists had matured, so too did they quickly begin to express their own taste and feelings in their works. As a result Novgorodian painting began to diverge from that of Byzantium almost from the start, doing so very gradually, but also very definitely. At first the main difference was one of mood, for in the twelfth and thirteenth centuries the newly established Russian church had often to contend with paganism which, though forbidden, survived by stealth. To counteract it, the church became imbued with something of the crusading spirit; icons were an immensely valuable means of furthering its cause, and a tinge of the church's militant zeal is in consequence often to be discerned in the faces of the saints who gaze out from these early paintings. Yet their ardour is gentle and serene, with little of the Byzantine severity about it. The oval of their faces is more pronounced than in Byzantine painting, and the colours used are more

11

vivid. These tendencies become more marked with the years, when the range of bright colours and glowing pastel shades is greatly extended.

The bulk of the early Novgorodian icons belong to the fourteenth century. In the earliest of these the Russian elements are already well to the fore, and by the last quarter of the century they emerge supreme. In the opening decades the native style is sometimes tentative and often verges on the heraldic, but highlights and hatchings to indicate the fall of draperies are in general use and are often carried out in white, or sometimes in pale shades of blue, green and purple. The figures are stockier than in Constantinopolitan art; the colours are good throughout, and often truly splendid, a magnificent red providing a glorious contrast to delicate greeny-blues, pearly-whites and a particularly lovely lemon-yellow. The flesh tints are usually ochre-coloured, while the modelling was produced by using paler tones of the same shade to pick out the highlights, which often took the form of two tiny, white, parallel strokes.

At the end of the fourteenth century, with the consolidation of the fully developed national style, a change of outlook occurred and the crusading note apparent in the earlier icons gave way to a more spiritual, more ascetic expression. This spirit may have come in answer to the increasing appeal of monasticism or it may have developed as an unconscious antidote to the manifold temptations with which increased prosperity seemed destined to lure man's soul towards the road to purgatory; whatever its cause, the effect is clearly apparent in the icons of the period. Still markedly linear in style, still devoid of all unnecessary details, with the impact made by the painting still as incisive as ever, the figures now become strangely elongated, in the intensity of their desire to reach unto heaven. Sometimes they stand on tip-toe, as if to narrow the gap, and their gestures, though still restrained, definitely indicate emotion, while their draperies, which are henceforth skilfully modelled, express a keener vitality in each of their white-hatched folds. Yet for all their elongation and their delicate, sloping shoulders, these figures possess the sturdy build of countrymen. Their noses still retain the slenderness of their Byzantine prototypes, but their heads are smaller and rounder, and their features are more definitely Slavonic in type. A livelier delight in sinuous lines and arresting contours is also characteristic and finds outlet in the patterns appearing in the backgrounds, whether these be in the form of clouds, of rocks or of architectural details. The colours are delicate yet intense, extremely varied and astonishingly clear, producing a splendour of tone and shade that has seldom been surpassed in mediaeval painting. The general excellence is further enhanced by the sureness with which the scenes are set in their backgrounds, for however elaborate the subject, however numerous the personages involved, there is never any feeling of crowding or constriction. The subject fits into its frame admirably, and the background is always well-proportioned to the scene.

Though anonymity remained the general rule among icon painters, three artists escaped it by acquiring great renown among their contemporaries. The first of these was Theophanes, known as the Greek, because he came to Novgorod from Byzantium. He reached Russia towards the middle of the fourteenth century, and by the thirteen-seventies he was already famous in and around Novgorod. His frescoes are to be numbered with the finest of the age, whether in the Roman Catholic West or the Greek Orthodox East. Some equally splendid icons are now attributed to him. In both, the drapery of the robes is magnificently moulded, and his saints retain the fierce spirituality of expression and his scenes the austere and sophisticated colour schemes of the Byzantine world. Nevertheless he became as Russian an artist as El Greco did a Spanish one.

Theophanes' significance is not confined to his achievements nor even to his influence on the average artist of his day; his importance is scarcely less great on account of the formative role which he exercised on the development of the art of Andrew Rublev. Rublev, the second of these artists, was born in Russia in about 1370. His name is first mentioned in connection with the redecoration of the Cathedral of the Annunciation in Vladimir, when Rublev must have had the opportunity of studying some of the finest ancient icons that existed there. Very little is known of his life, and it is not clear when he first met Theophanes. By 1405, however, he was working as the latter's assistant on the mural decorations of Moscow's first Cathedral of the Annunciation. By this time Rublev had become

a monk of the Spas Andronievsky Monastery in Moscow, where he spent the remainder of his life, dying there in about 1430. He is the greatest of all Russian mediaeval painters, as fine in his way as the foremost Italian primitives. His best known work – the icon of the Old Testament Trinity – was not revealed in its full splendour till the year 1909. Like his other surviving works it is permeated with the gentle, calm, deeply religious spirit which inspired him and which he was able to infuse into his paintings, where it expresses itself by means of remarkably sensitive and fluid drawing, and very delicate, harmonious colours. Rublev made a profound impression on the artists of his day and his influence is apparent in many works of the period. As he established a workshop in which he employed assistants, it is often very difficult to determine the exact authorship of an icon of the Rublev school.

Dionysius, the third outstanding painter, also had a workshop in which his assistants worked, and his skill likewise won him a great many followers; but there the resemblance between him and Rublev ends. Dionysius was born in about 1440 and died in 1505, and his paintings reflect the restless, enquiring spirit of this more turbulent age. Though his colours are less brilliant and the faces of his figures less alive and individualistic than in fourteenth-century Novgorodian icons, his presentation is more elaborate, clearly reflecting the interest he felt in the technical aspects of painting, more particularly with regard to composition and perspective. He laid more stress on gesture and emotion than had been done before, but a certain restless elegance sometimes detracts from the spiritual intensity of his paintings, fore-shadowing, however faintly, the dawning dissatisfaction with the old iconographic tradition.

This dissatisfaction was felt most strongly in Moscow, though the final break was not to occur till late in the seventeenth century. In the past Moscow had produced artists of great quality, who conformed wholeheartedly with the existing traditions. Then, when the fall of Constantinople to the Turks in 1453 invested the young capital with new significance, an era of prosperity dawned which produced a moneyed class able and willing to spend on art patronage. The presence in the capital as tsarina of a Byzantine princess with an Italian education, and the arrival in Moscow of a group of Italian architects to whom the tsar entrusted much important work in the city, created a new awareness of art and evoked an entirely novel concern over beauty. Merchants and noblemen now became anxious to own icons of artistic merit, and icon painters who had formerly been primarily concerned with the emotional and spiritual content of their paintings now strove to invest them with a specifically pictorial quality. The result is reflected in the icons of the period, for many tend to be more pleasing and decorative, if less intense and spiritual, than those of Novgorodian school.

As the years slipped by, these tendencies gathered momentum. The artists employed by the tsars in the royal workshops installed in the Palace of Arms and those working primarily for the Stroganovs – a family of merchant princes, who were great lovers and patrons of icon painting – inclined more and more towards a stylised naturalism which they combined with an almost exaggerated fondness for a mass of minute detail. Though they elongated the human figure even more than had been done formerly, yet they shortened the architectural features and reduced the floral and animal figures with which they enlivened their backgrounds, so that even their largest icons acquired something of the character of an eastern miniature. If they lacked the spiritual intensity of the earlier painters, they nevertheless remained sincere artists, and artists of very high quality. They were, in addition, conscious artists, and because of this they often signed their works. Their style appealed especially to connoisseurs, and this may well explain why many of their paintings also carry on the reverse of the panels the names of the patrons who commissioned them. These represent the last flowering of Russian mediaeval painting, for the traditional style rapidly deteriorated when brought into touch with western naturalism. Peter the Great's reforms accelerated the process, putting a quick end to any possible form of evolution within the iconographic framework. The old style meandered on as a craft, producing an occasional icon of merit; yet in the past it had been a fine art, enriching the world with masterpieces as lovely in their own way as are any of the religious pictures of the Italian and Flemish primitives.

THE PLATES

PLATE 1

Icon of St Michael

Second half of the fourteenth century. Early school of Novgorod, though the panel may be by the hand of a painter from Pskov. Formerly in the Riabushinsky collection, now in the Tretiakov Gallery, Moscow.

Kondakov was not destined to see some of Russia's finest twelfth- and thirteenth-century icons, for it was not until many of the panels had been cleaned by the skilled staff of the USSR's Restoration Workshops of Moscow in post-revolutionary years that the original paintings were brought to light. The fine icon of St Michael reproduced on this plate is, however, to be numbered among the earlier works known to Kondakov.

The icon was probably originally intended as part of a Deesis★ group for the main register of an iconostasis. It belongs to the third quarter of the fourteenth century, when Russian painters had broken free from Byzantine tutelage, and in consequence there is much in this painting to distinguish it from its Byzantine prototypes. Thus the very simple, candid and gently forthright presentation of the figure, the mastery with which space is related to matter, and the instinctive feeling for outline are all essentially Russian features. The somewhat free treatment of the face, with its rather more naturally shaped oval, and rounder, if still Byzantine-like deep-set eyes, are no less characteristic of fourteenth-century Novgorod. Essentially Russian, too, are the white contour lines on the face, the decorative treatment of the wings and the rhythmical coils of the saint's hair, which rises impressionistically to form a point in the centre of his forehead, stressing thereby the deep absorption of his face.

The paint is laid on flat, with the folds of the costume somewhat rigidly delineated. The colours, though limited in range, are luminous in tone and grand in effect, the splendid wings standing out magnificently from the silvery-blue ground.

★ See Plate 9.

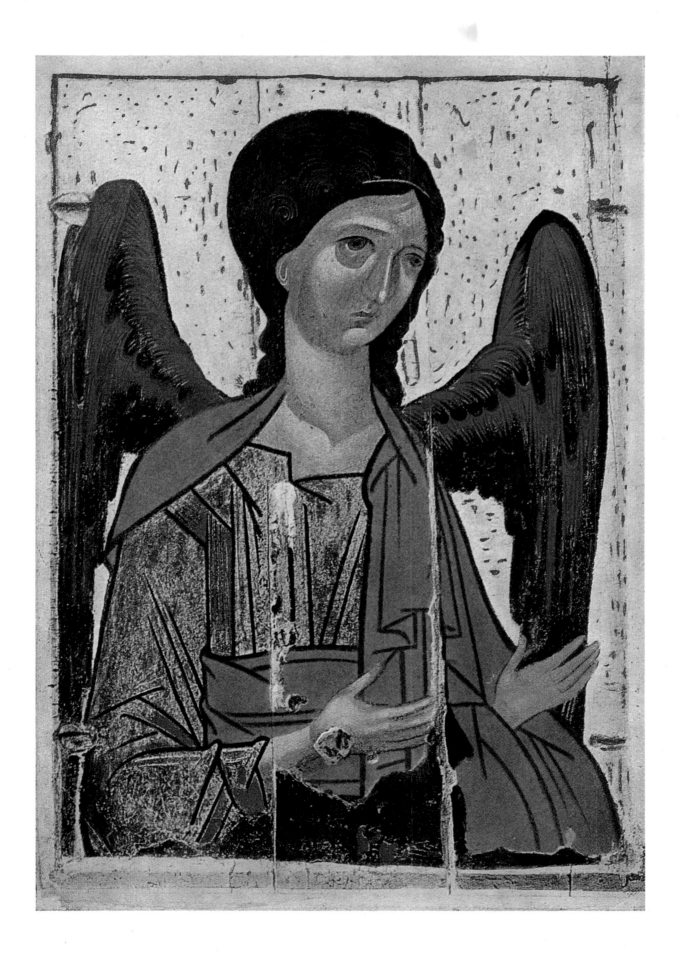

PLATE 2

Icon of the Archangels Gabriel and Michael holding a medallion bearing the Christ Emmanuel

Late fourteenth century. School of Novgorod. Formerly in the Ostroukhov collection.

This interesting, if somewhat archaic, icon is very close in style to a twelfth-century panel of the Annunciation in the Tretiakov Gallery in Moscow, and also to a series of thirteenth- and fourteenth-century frescoes of the Novgorodian school, more especially to certain murals in the Mijorski Monastery near Pskov. The earlier panel is more finished and accomplished in style than this icon, which is a little ponderous, notwithstanding the undoubted grandeur of its conception and the genuine depth of its feeling. Nevertheless, the figures of the archangels are marred by a touch of heaviness, and the painting of their wings and of the ground on which they stand is a little rough. Attempts at modelling, carried out in the faces by means of pale ochre highlights, or 'bliki' as they are called in Russian, and effected in the draperies by the introduction of white hatchings, are still in the experimental stage and not as yet altogether satisfactory. They suggest a provincial, though skilled, hand. The alternation of reds and blueish-greens is characteristic of Novgorodian painting of the period and is introduced here with considerable ability and success.

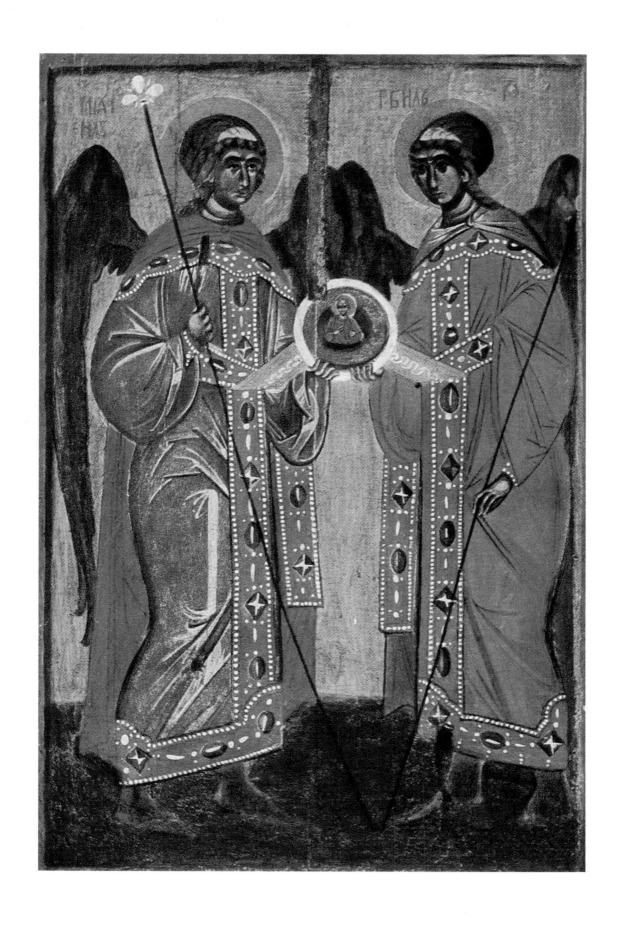

19

PLATE 3

Icon of St Elias

Late fourteenth or early fifteenth century. School of Novgorod. Formerly in the Ostroukhov collection, now in the Tretiakov Gallery, Moscow.

St Elias was greatly venerated in Novgorod, where he was regarded as the Giver of Rain and the Protector from Fire. His role was especially important in the latter capacity, for fire was one of the direst calamities which mediaeval Russia had to contend against. As the domestic architecture of the country was carried out entirely in wood, an out-break in an urban area, however small at the start, generally resulted in the destruction of an entire district. Because of his special association with fire, St Elias was generally represented against a fiery red background. In this instance the red is of that particularly vivid shade which is to be associated with the finest period of Novgorodian painting.

The years which elapsed between the painting of this icon and the one illustrated on the preceding plate were responsible for several stylistic changes. Thus, in the interval, the saint's face has become more Russian-looking, his eyes are rounder and more naturalistic in shape, and the lines of his nose are extended to form the finely arched eyebrows which frequently appear in Russian paintings of this date. His hair still rises to the characteristic peak at the parting, the paint continues to be laid on flat, and contour lines underline his eyes, but a little cross hatching appears to indicate the muscles of the face and neck, and attempts are made at modelling drapery. The Russian fondness for decorative design is reflected in the balanced arrangement of the beard and hair, and the saint has the sloping shoulders which are to be seen on most fifteenth-century Novgorodian icons.

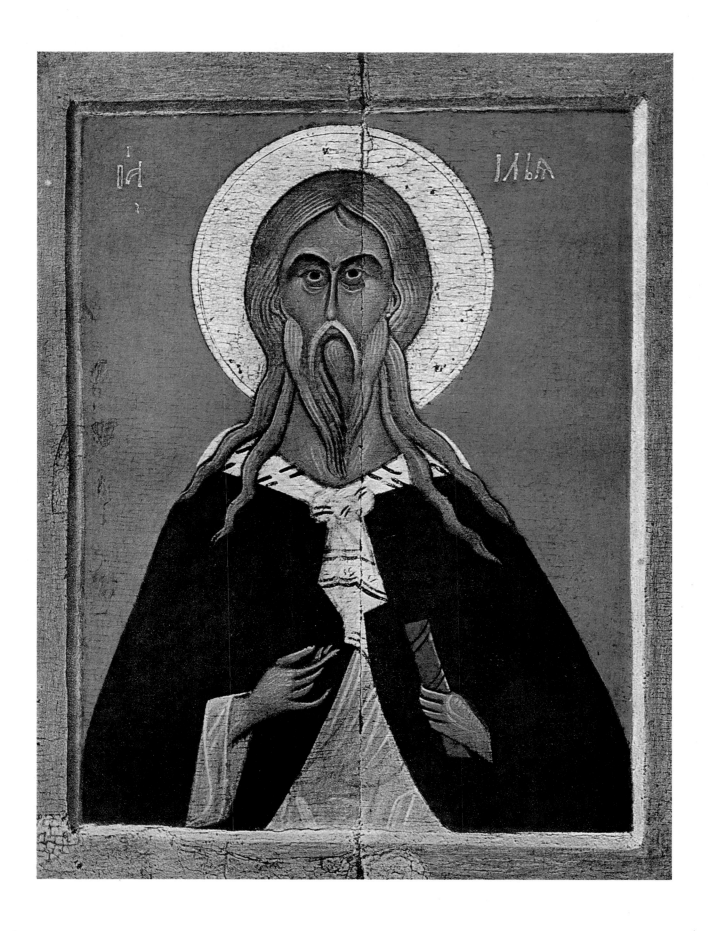

PLATE 4

Icon of the Virgin of Smolensk

Fifteenth century. School of Novgorod. Formerly in the Riabushinsky collection.

This iconographic type, showing the Virgin either standing or half length, holding the Child on her left arm and pointing to Him with her right hand, was known in Byzantium as the Virgin Hodegetria, that is to say 'Pointer of the Way'. The original version was thought to have been sent from Jerusalem by the empress Eudoxia, the wife of Theodosius the Younger, some time before her death in 453 A.D., to her sister-in-law, Pulcheria. The icon was so greatly beloved in the Justinianic era that it was adopted as the emblem of Byzantium, and, in the seventh century, legend ascribed it to the hand of St Luke. In the fourteenth century a Byzantine version of the original was brought to Smolensk cathedral, and soon after miraculous powers were attributed to the icon. The version illustrated on the accompanying plate adheres closely to the original iconographic type, but the overstressed shadows beneath the eyes suggest that the painter no longer fully understood the Byzantine idiom and that he was repeating a stylistic mannerism which had little meaning for him. Even so, this is a painting in the grand manner, its solemnity rendered the more impressive by its severe, dignified colours.

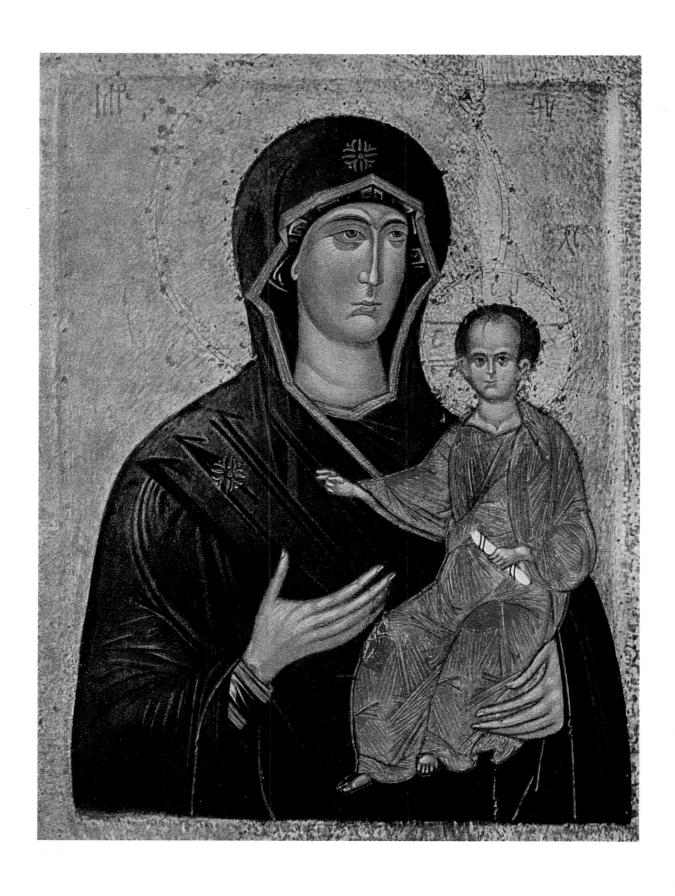

PLATE 5

Icon of the Virgin and Child

Early sixteenth century. School of Novgorod. Formerly in the Riabushinsky collection.

This variant of the Hodegetria representation of the Virgin is known in Russia as the Virgin of Jerusalem, but in this instance the painter has made a mistake, for, by inadvertently reversing a tracing from a Podlinik, he has placed the Child on the Virgin's left arm instead of on her right, as He appears in the correct rendering. The icon which gave rise to this iconographic type hung for many centuries in Jerusalem, but it was no longer there when the Russian pilgrim, Prior Daniel, reached the city in the latter half of the twelfth century. In 1390, however, another Russian pilgrim, the deacon Ignatius, saw it in a place of honour in the Cathedral of St Sophia in Constantinople.

This iconographic rendering differs from that of the Hodegetria in that, apart from the Child being held on His mother's right arm, He is also shown with His face raised towards hers, and she too inclines her head towards His. This gentle and more natural attitude quickly endeared itself to many people and led to the creation of a number of more intimate iconographic types of the Virgin and Child, such as the Virgin of Tenderness, the finest example of which is the beautiful twelfth-century Byzantine icon of the Virgin of Vladimir.

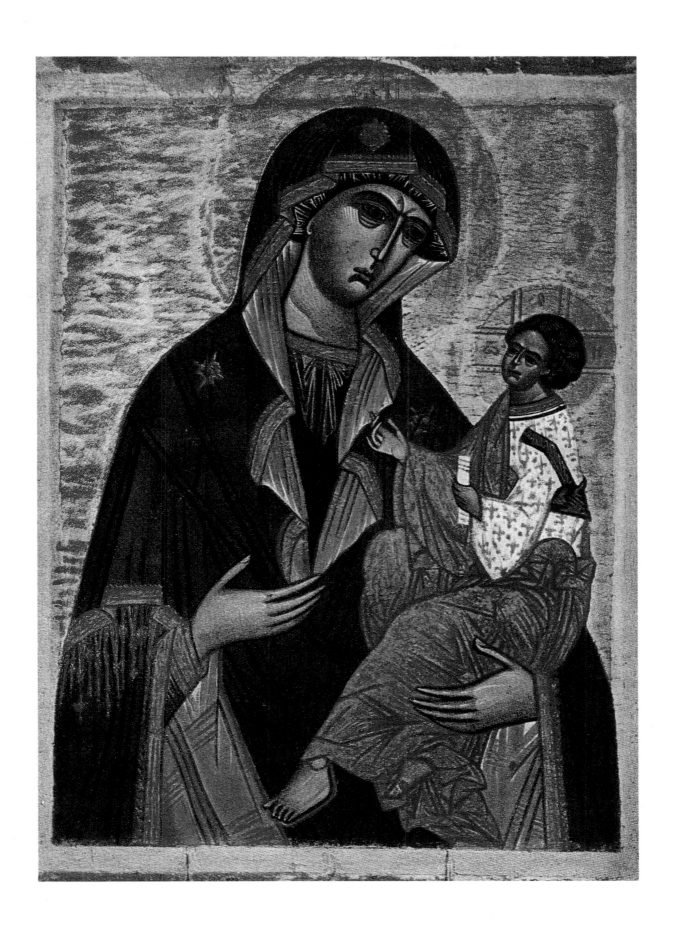

PLATE 6

Detail from an icon of the Vernicle or Holy Mandylion of Edessa

Early sixteenth century. School of Novgorod. Formerly in the Ostroukhov collection.

This iconographic type is one of a series of Our Lord's Face, known as Our Saviour's Picture Not Made with Hands, and further qualified as Our Saviour of the Wet Beard because of the unusually pointed shape of His beard. Although the painting may not be altogether satisfactory aesthetically if regarded purely as a picture, it is, nevertheless, remarkably impressive when seen in its proper place in the prophets' tier of an iconostasis. Its technical interest is considerable, for it illustrates very clearly the method followed by the icon painters of Novgorod in the facial treatment of their paintings. Notwithstanding the curious flatness of the cheeks and the schematic distortion of the ears, the face is strikingly convincing, and even though every trace of dramatisation is banished from it, the final impression is one of deep feeling, intense compassion and great suffering. Much of the effect is achieved by the two parallel lines marking the Saviour's forehead, but the characteristic white underlining of the eyes is also responsible for some of the intensity. The treatment of the face is basically graphic, the symmetry of the moustache, beard and hair being especially marked. The tragic note is softened by the introduction of a decorative halo, in place of the more customary gold-coloured one, as well as by that of gold embroidery on the veil.

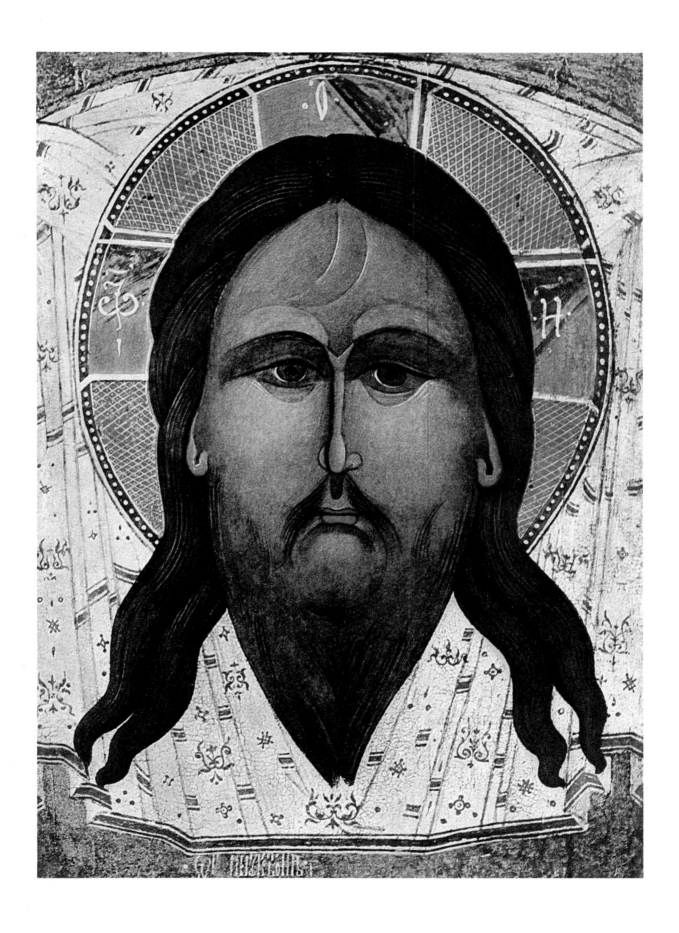

PLATE 7

The Virgin of Konevetz

Late fifteenth or early sixteenth century. School of Novgorod. Formerly in the Ostroukhov collection.

This icon of the Virgin and Child is generally called Golubka ('of the dove') in Russian because of the dove held by the Child. It follows the lines of the famous miraculous icon of the same name brought from Mount Athos in 1395 to the Monastery of Konevetz on Lake Ladoga. Kondakov traces the origin of the type back to northern France, whence it reached Italy, becoming very popular there in the fourteenth century. From Italy it passed to Greece, reaching Russia in the course of the same century. In both the Italian and Russian versions the Child holds the dove in His left hand and a bundle of string, one end of which is secured to the bird's leg, in the other.

This icon is of somewhat later date than the panel at Konevetz and the faces have suffered from a later repainting which awaits removal; even so, the high quality of the work is clearly evident, and the icon is additionally enhanced by the lovely metal cover or 'riza', as it is called in Russian, which is contemporary in date.

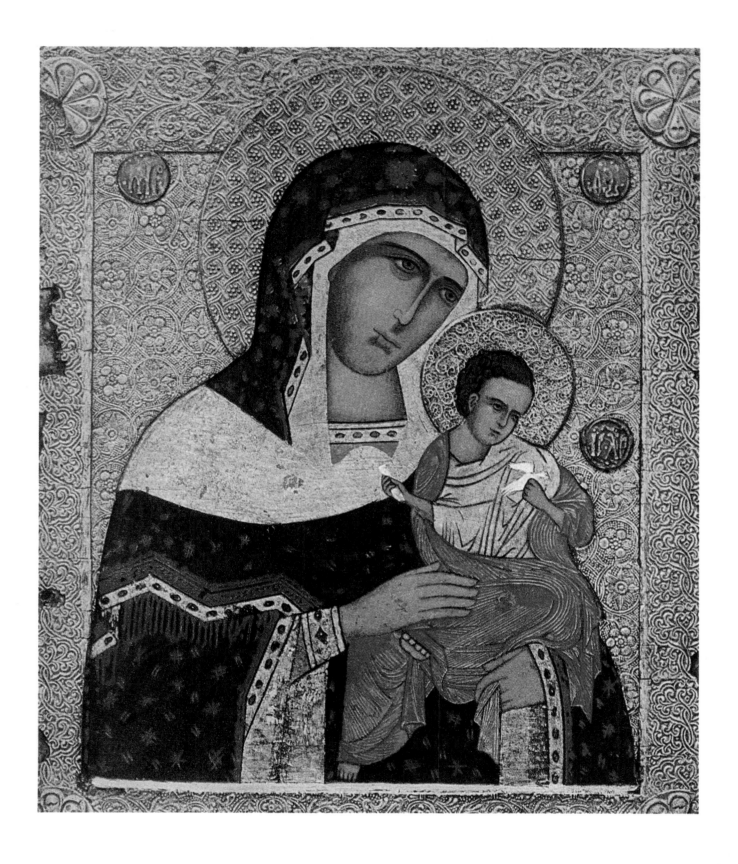

PLATE 8

Icon of the Choir of the Holy Archangels

Sixteenth century. School of Novgorod. Formerly in the Ostroukhov collection.

The fifteenth century saw the introduction of a series of themes which Kondakov defined as the mystico-didactic. The Choir of the Archangels is one of these. It is in effect little more than an elaboration of the archangel type of icon illustrated on plate 2, with the difference that seven archangels are represented on it instead of two. Occasionally the seven are accompanied by a group of angels, the assembly thus formed relating sometimes to the archangel Gabriel, sometimes to Michael, the accompanying inscription giving the designation. In the case of the icon illustrated on the accompanying plate, the inscription refers to both archangels.

The icon is painted in the delicate colours characteristic of the fifteenth-century Novgorodin school; the treatment of the figures is monumental and the grouping excellent, but the outlines are a little heavy, and although the faces closely follow the traditions and contours of the Kievian age, they lack the inspiring passion of that period.

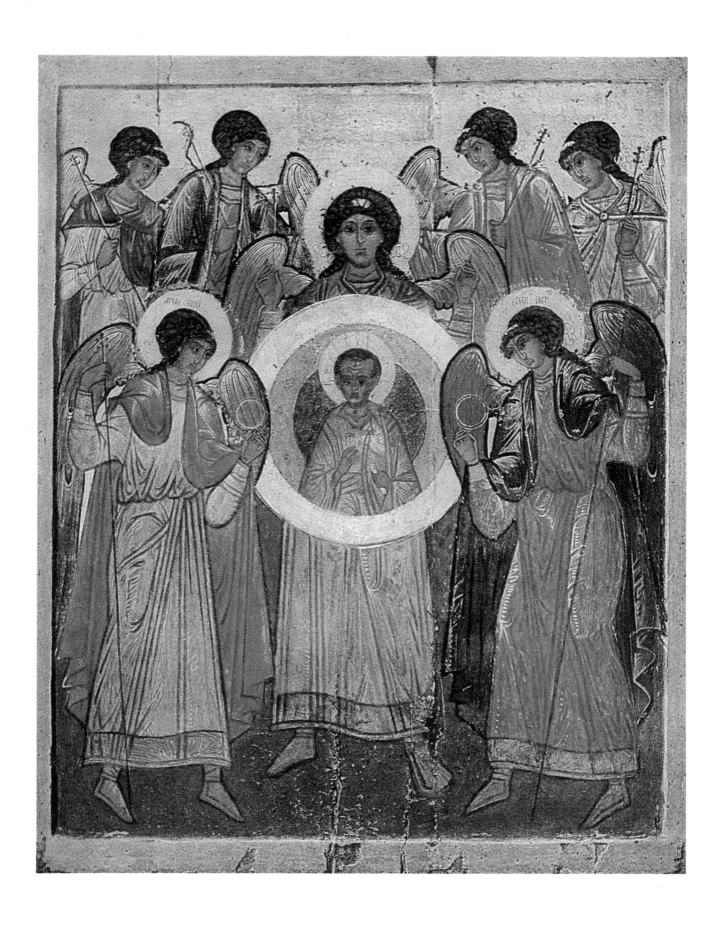

The Deesis cycle

First half of the fifteenth century. School of Andrew Rublev, following the traditions of Vladimir Suzdal.
Formerly the property of the Monastery of St Nicholas, Moscow.

The 'Deesis' or 'Supplication' group is one of the oldest in Greek Orthodox iconography. Its origins go back to early Byzantine times, to the days when the altar was separated from the body of the church by a stone or marble screen with the head of Christ cut above its central arch. Somewhat later, the Virgin's head was added to the screen, appearing on the right of the Saviour's, then that of St John the Baptist was added on His left. With the years the sculptured heads tended to get replaced by painted ones. From this it was but a step before the paintings were transferred from the marble screen to transportable wooden panels. For a time each head continued to appear on a separate board, then, possibly under the influence of the monumental mosaic and painted decorations carried out on the walls of the great churches of Byzantium, it became customary to show the three heads, now extended to include part of the bodies, on a single panel. Later still it became as usual for the three holy personages to be shown on a single icon as on separate panels, full length or bust size. In pre-Mongol Russia, notably in the principality of Vladimir Suzdal, angels were sometimes substituted for the Virgin and St John, but this practice did not persist for very long.

In the fourteenth century, doubtless because of the scarcity of good building stone, the Russians replaced the stone screen with an elaborately carved and painted iconostasis, which served both as a screen and as a stand for icons. From the start the position of each icon on the iconostasis was carefully defined. As a result, so long as the Deesis consisted of a single icon, its place remained in the bottom tier of the iconostasis, but when it appeared on three separate icons it was raised to the second tier, coming above the tier reserved for the icons depicting the Church's Festivals. In this case two large fixed icons, one appearing on each side of the Royal Doors opening on to the altar placed in the main apse, filled the vacant spaces.

When the Deesis icons were raised to the second tier, they were generally flanked on either side by icons showing the archangels, the apostles and fathers of the church, the entire composition being called a 'tchin', meaning 'rank'. When the group consisted of seven personages it was known as a 'Sedmitza' or 'seven day', meaning a week, but on other occasions the tier was named that of the 'Sviatitely' or 'Holy Fathers'.

The Sedmitza tchin illustrated on the following seven plates closely follows the style of painting associated with Vladimir Suzdal, but the drawing bears the imprint of Rublev's influence, and, in addition, the seven paintings closely adhere to a very similar group of Byzantine icons which the first abbot of the Visotsky Monastery, in the district of Serpukhov, purchased in Constantinople and dispatched to his monastery between the years 1387 and 1389.

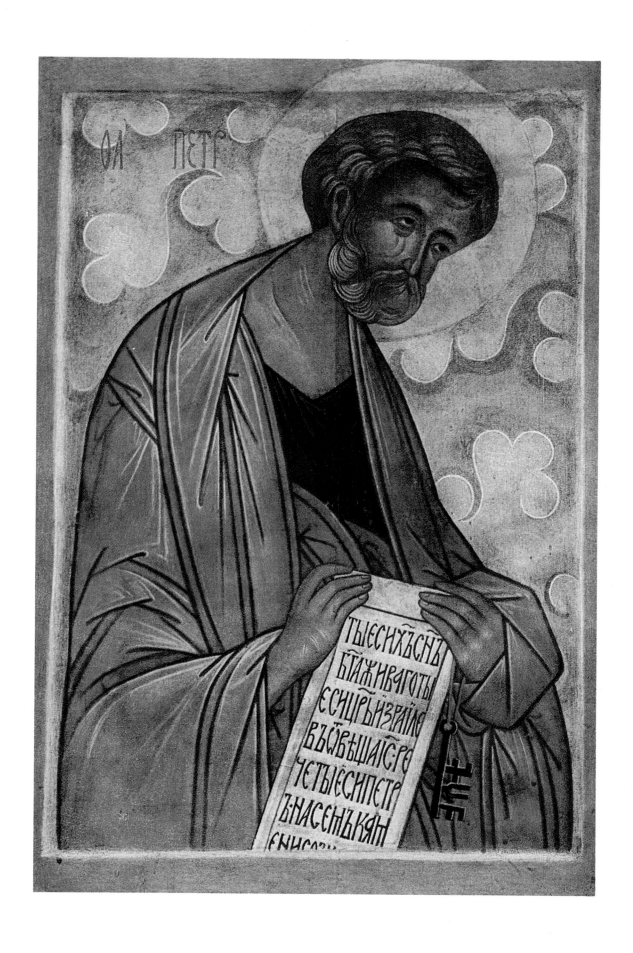

33

PLATE 9

[see previous page]

The Deesis Cycle: St Peter

School of Rublev. First half of the fifteenth century.

Considering the 'Sedmitza' from left to right, the first icon represents St Peter. This fine painting embodies all the salient characteristics of the fifteenth-century style. Foremost amongst them is the love of the rounded line; it finds expression first in the saint's sloping shoulder, then in his inclined head, which repeats the curve of the shoulder; it recurs anew in the rhythmical waves of his hair and is emphasised yet again in the very unusual background formed of stylised, convoluting clouds. The drawing is confident and flowing, and the spacing of the elongated figure and its relationship to its background are admirably attuned. The face is very delicately modelled, a paler shade of the ochre flesh tint being used for the purpose.

PLATE 10

The Deesis Cycle: The Archangel Michael

First half of the fifteenth century

The archangel Michael comes next to St Peter on the iconostasis. The colouring of this icon is superb, clearer and more brilliant than in any others in the tchin. Again the figure is elongated to express the archangel's celestial origin, and notwithstanding its ornateness and elegance, the treatment remains as direct and unfussy as ever, the line as delicate, flowing and assured. The grace of the painting comes very close to that of Rublev's works, and the icon may well be by his hand.

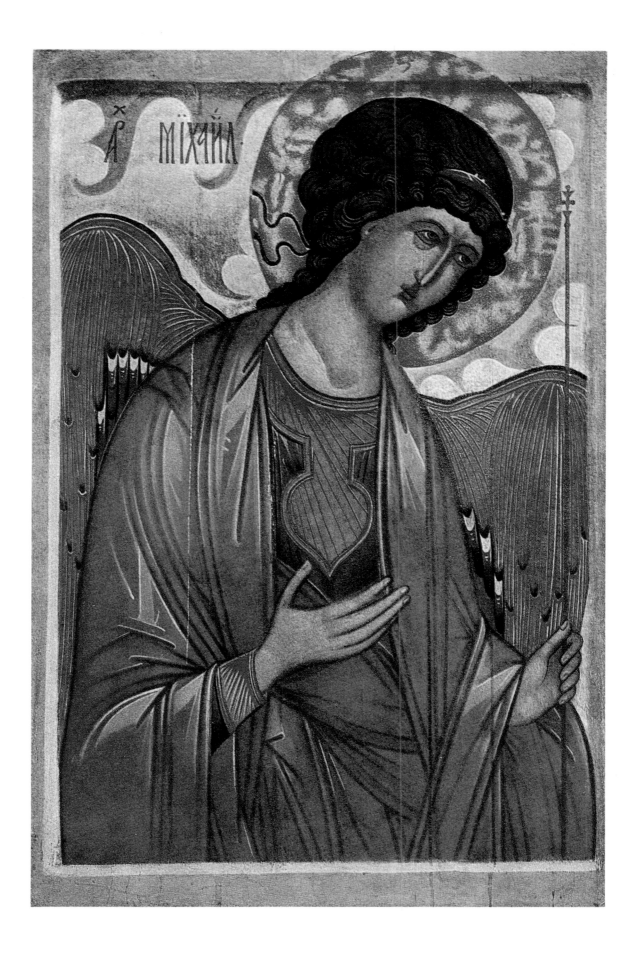

35

PLATE 11

The Deesis Cycle: The Virgin

First half of the fifteenth century

The Virgin follows St Michael on the iconostasis. For all its restraint, this painting depicts grief at its most poignant; the Virgin's eyes are swollen by unshed tears, her nose pinched with sorrow, her lips compressed by pain. She stands with one hand directed towards the Saviour in the traditional gesture of supplication on behalf of mankind, whilst with the other she holds her robe. Each contour is eloquently outlined, constantly emphasising and recalling the rhythm of the curved line which plays such an important part in this composition. If not by Rublev, the icon must be by a hand no less skilled than the master's.

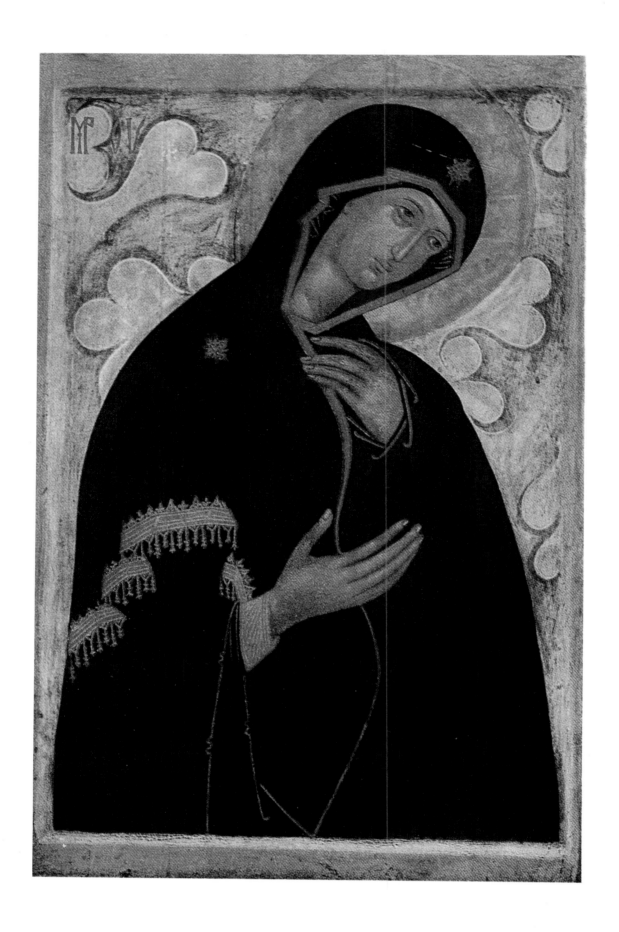

PLATE 12

The Deesis Cycle: The Saviour

First half of the fifteenth century

The Saviour forms the centre of the 'tchin'. The same characteristics are inherent in this icon as in the rest of the group, but something of the fine intensity of the renderings of the Virgin and St Michael seems lacking in His serene countenance. Yet there is nothing sentimental or vacuous in this very accomplished painting.

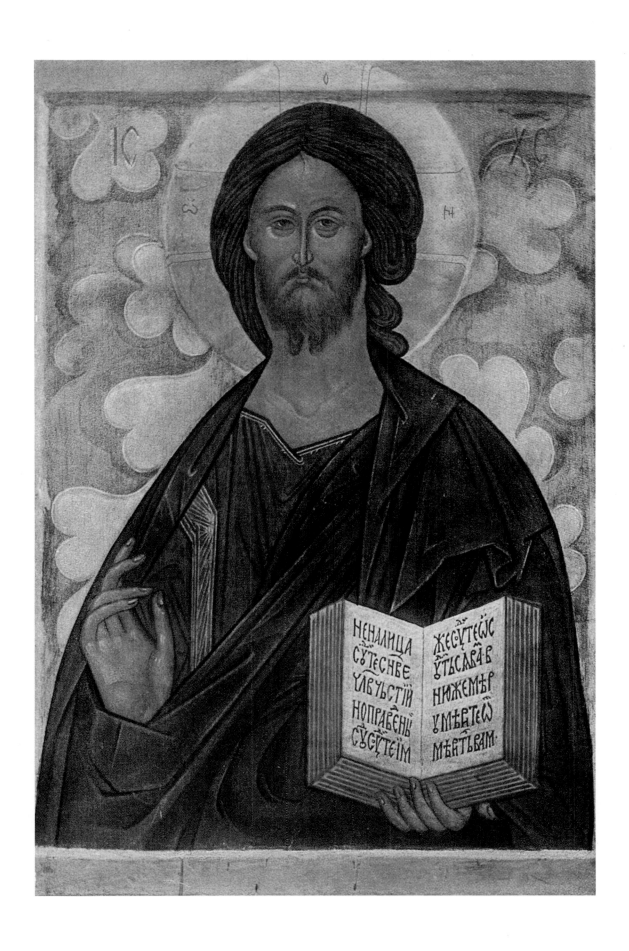

PLATE 13

The Deesis Cycle: St John the Baptist

First half of the fifteenth century

St John the Baptist, who appears on the Saviour's left, once again depicts deep sorrow. His hands are raised in supplication, as were the Virgin's, for in the Deesis group, both implore the Saviour to intercede with His father on behalf of erring humanity. St John's face is splendidly modelled, pale ochre highlights being skilfully used to emphasise his suffering. The characteristic vertical lines mark his forehead, and his hair harmonises with the ochre colour scheme, which proves singularly effective when seen in conjunction with the other icons of this group.

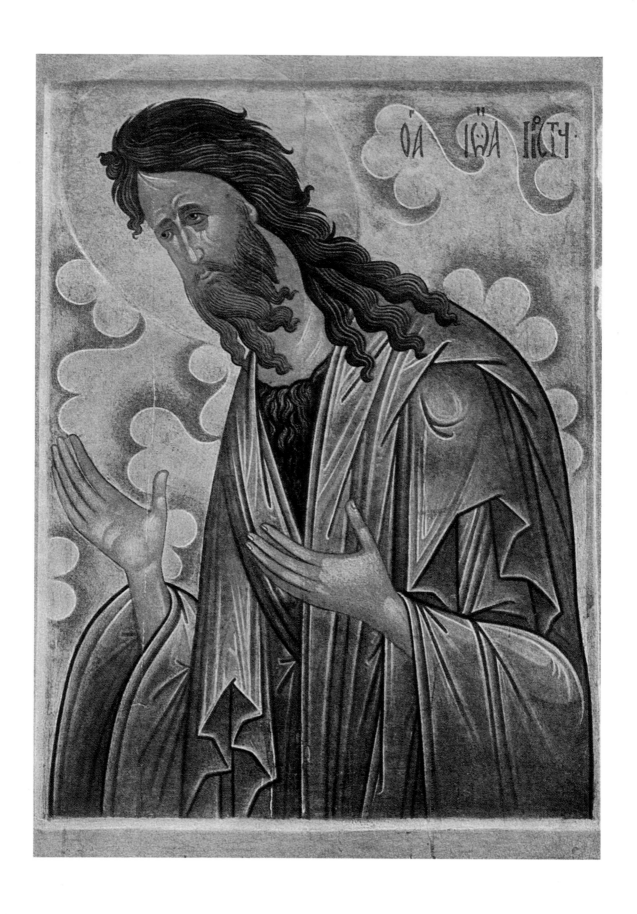

41

PLATE 14

The Deesis Cycle: The Archangel Gabriel

First half of the fifteenth century

The archangel Gabriel comes next, providing a deeper, quieter note of colour. The touch of pink which appears at the base of his wings is a masterly addition, for it helps to give depth and animation to the figure.

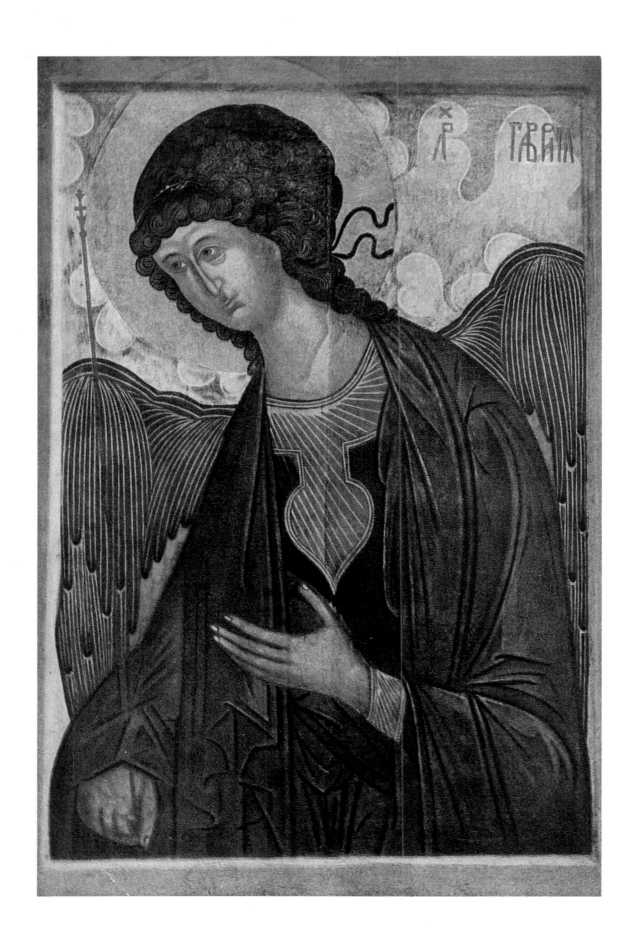

43

PLATE 15

The Deesis Cycle: St Paul

First half of the fifteenth century

St Paul closes the series. As in the case of St Peter, who opened it, the more naturalistic treatment of his face and more especially the less stylised oval of its shape, are signs of his terrestrial origin. The same stylistic trends prevail in all the panels, the clouds in the background forming in each case an integral part of the linear composition. The colour scheme of each icon, wholly satisfactory when seen singly, reveals, when viewed as a group, gentle gradations of great suppleness and beauty.

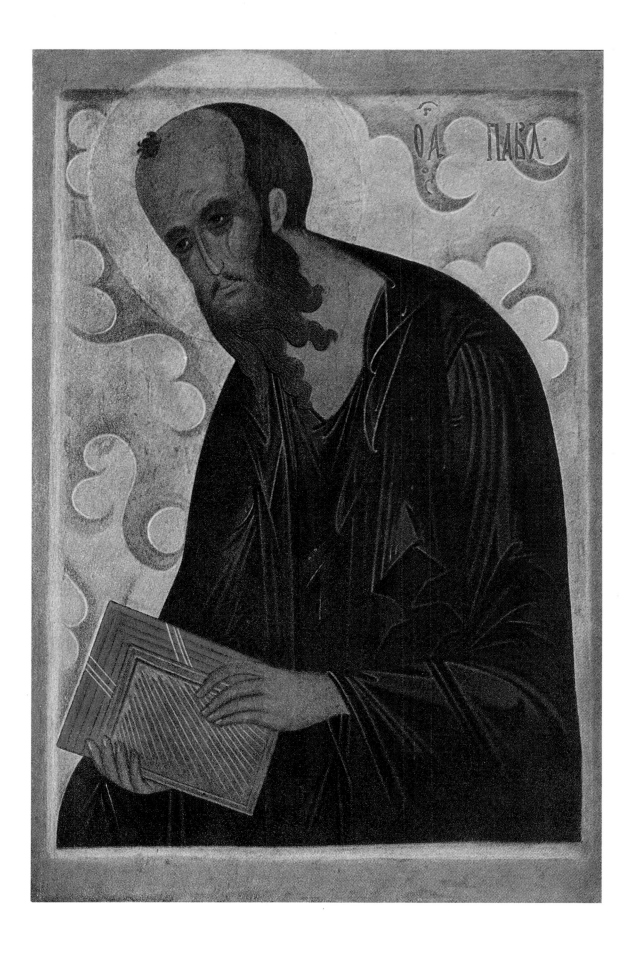

PLATE 16

Icon of the Nativity

First half of the fifteenth century. School of Novgorod. Formerly in the Ostroukhov collection, now in the Tretiakov Gallery, Moscow.

This is the traditional iconographic rendering of the scene, showing the cave at Bethlehem still exposed to the skies, as it was before Constantine built his great church over it. The ass and the ox stand in its opening, gazing at the Child lying in a portable manger. The recumbent figure of the Virgin occupies the centre of the painting, lying on a crimson rug amidst the rocks and vegetation of Palestine. The three kings and a shepherd appear on either side of her, having been guided to the spot by the angels shown in the upper register; below, Joseph hears of the Child's birth whilst attendants bathe the Babe. Three saints gaze down upon the scenes from the centre of the icon's upper margin. They are St Eudoxia, St John Lestvichnick and St Juliana, whose presence there may be explained by the probability that the people who commissioned the icon were named after them.

The scenes are presented in the simple, direct manner characteristic of the period, but the contemporary items of clothing worn by the secular figures are unusual. The drawing is flowing, linear and clear-cut, the colours luminous and excellently balanced, and the elimination of all unnecessary details is yet another early feature.

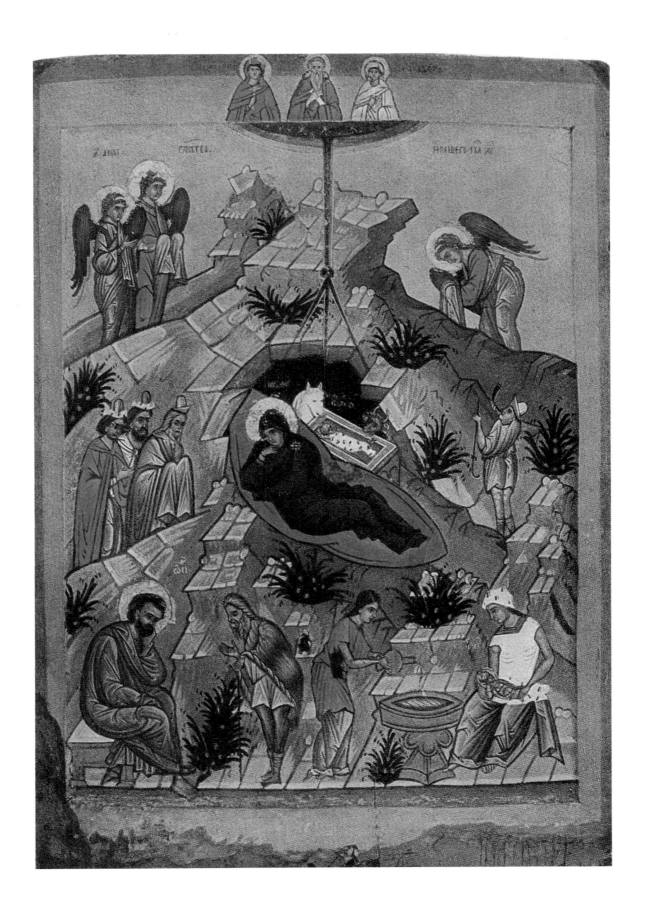

PLATE 17

Icon of the Ascension

Second quarter of the fifteenth century. By a follower of Rublev working in the style of Dionysius.
Formerly in the Riabushinsky collection.

This lovely icon was probably intended for the Festival tier of an iconostasis. It is typically Novgorodian in the excellence of its colour scheme and in the sureness of its composition. The harmony and effectiveness of the various tints used in it have seldom been surpassed in the art of the period. A strip of gold horizon ingenuously separates the white background of the icon from a range of greenish-white mountain peaks, which rise steeply at either side of the panel, white highlights marking their jagged contours. The risk of any monotony inherent in the use of two parallel lines to mark the cleavage between the celestial section of the icon and the terrestrial is skilfully avoided by the introduction of an almost equally symmetrical device which – consisting as it does of four trees of different shapes but of almost equal height – breaks the flatness of the horizon at four equidistant points, carrying the eye upward. There, poised in heaven, two angels support Christ before a mandorla or glory. On earth, the mountains assume the role of a backcloth for the two angels clothed in pearly white, who, in their turn, serve magnificently to offset the Virgin's figure clad in garments of splendidly coloured blue and purple. The apostles are grouped on either side, their garments enlivening the painting by their vivid, delicate, typically Novgorodian shades.

Rublev's influence predominantes in the painting of Christ and His supporting angels, but that of Dionysius prevails in the case of the Virgin and the apostles surrounding her. These figures are elongated, some standing on tiptoe to add to their height; their poses and expressions are dramatic, their heads, hands and feet are small, and their draperies are admirably modelled, the white hatching being most ably introduced. It is indeed very apparent that the painter was intent on producing a beautiful, lyrical painting as well as a deeply religious one. This conscious striving for aesthetic beauty marks a new phase in the history of icon painting, and the panel must therefore be assigned to the transitional period of Novgorodian art.

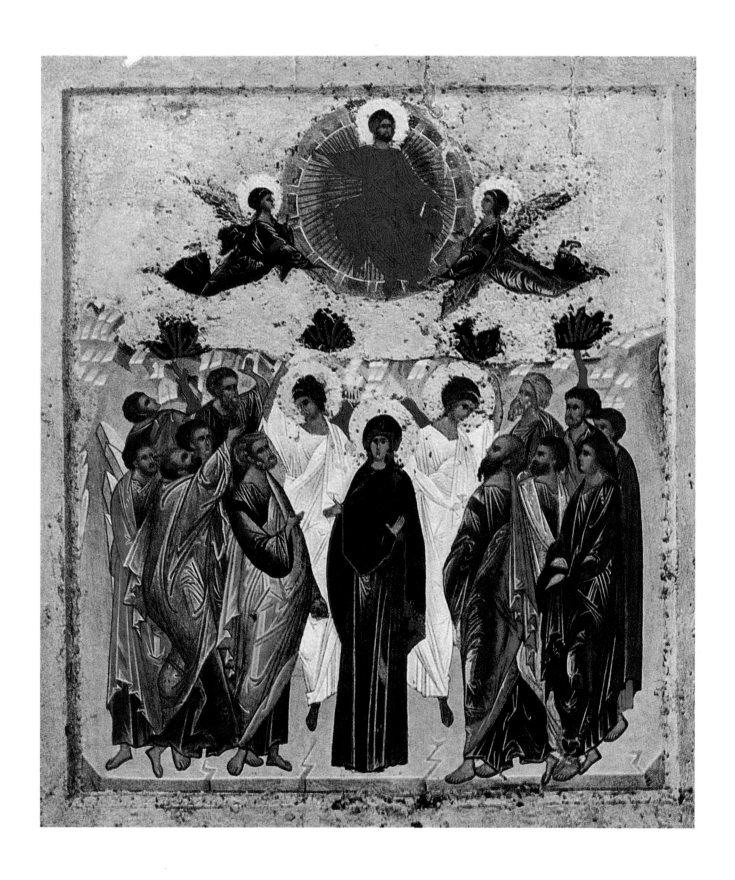

PLATE 18

Icon of St George and the Dragon

First half of the fifteenth century. School of Novgorod. Formerly in the Ostroukhov collection, now in the Tretiakov Gallery, Moscow.

St George was the subject of special veneration in and around Novgorod and the districts of Dvinsk and Viatka, where he was regarded as the Protector of Cattle and the Guardian of Flocks.

On this icon St George is shown against the white ground which is characteristic of Novgorodian painting, but the exclusion of all detail from the background is unusual. It led Kondakov to believe that the icon adheres to a very early form, an opinion borne out by the decoration on the saint's shield, which consists of the pagan emblem of the sun. Sun worship had been widespread in pre-Christian Russia, and sun emblems survived even to contemporary times as decorations on the wooden toys the peasants made for their children. The appearance of one of these on an icon suggests the loss of much of its earlier religious significance by the fifteenth century, at any rate in Novgorod, where it survived purely as a decorative device.

In accordance with the slightly archaic style of the icon there is still relatively little modelling of the face, but the colour range has widened to include most of the shades found in the later Novgorodian palette, that is to say, pearly whites, vivid reds, quiet touches of black, browns and darker greens and blues. Only the distinctive lemon yellow and the full range of pinks and blues are lacking.

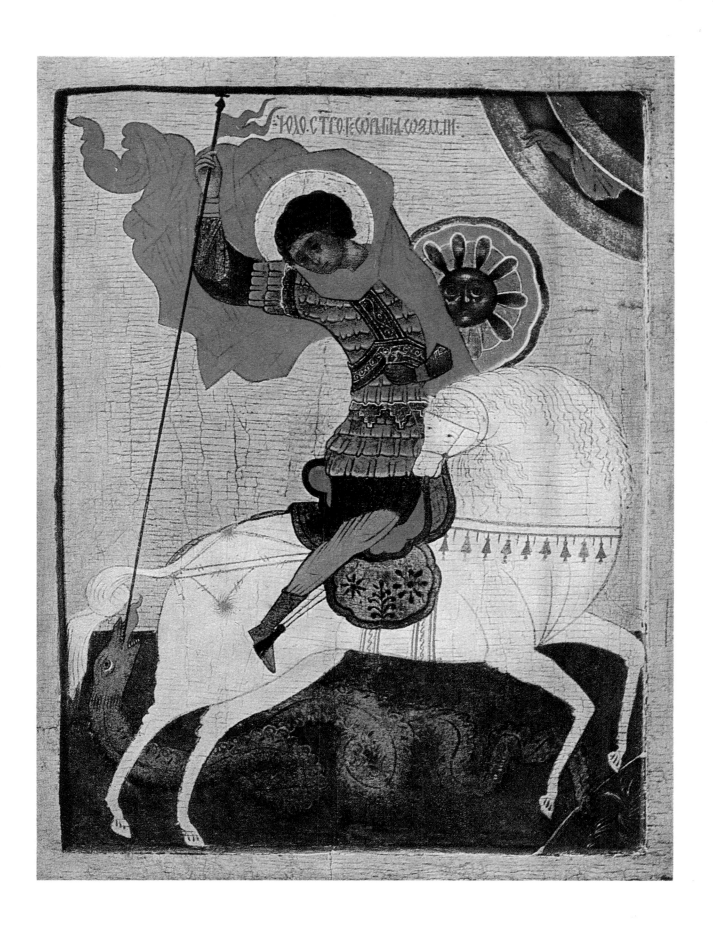

PLATE 19

Icon of St George and the dragon

Late fifteenth century. School of Novgorod. Formerly in the Ostroukhov collection.

This somewhat more ornate icon follows the same lines as that illustrated on the preceding plate. Once again the horse is treated in rather a heraldic manner, suggesting that the painter had spent part of his life in a region where certain ancient artistic traditions continued to survive. There is, on the other hand, considerable realism in the rendering of the mounted figure, who sits his horse with all the assurance of a practised rider. Something of the humanistic spirit of the Renaissance is reflected in the saint's gentle face as well as in the elegant curve formed by his arms and the glorious swirls of his great cloak.

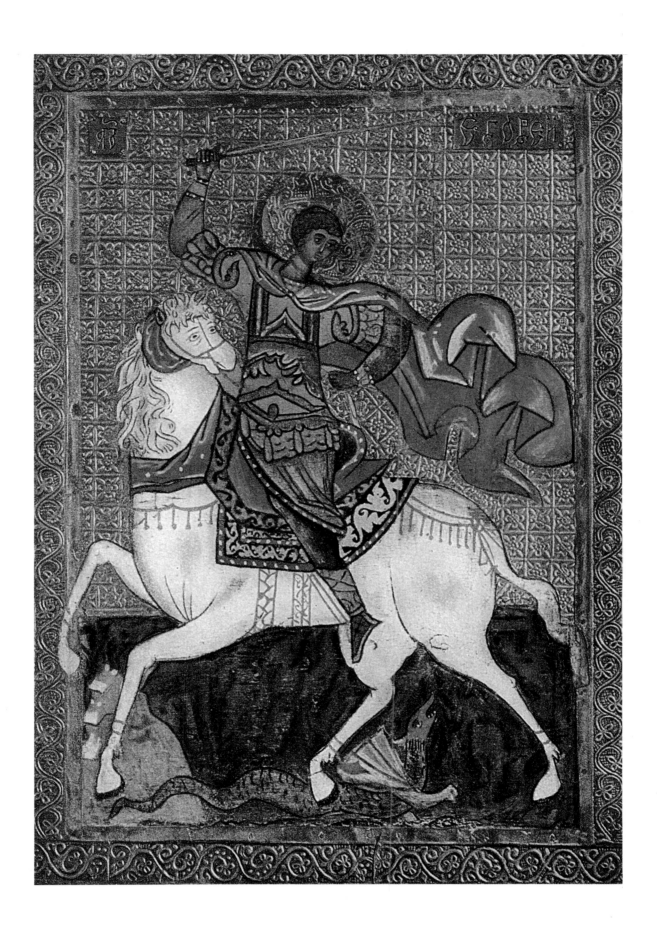

PLATE 20

Icon of St Boris and St Gleb

Late fourteenth, early fifteenth century. School of Novgorod. Formerly in the Riabushinsky collection.

The brothers were princes who, according to one tradition, were the sons of the Great Prince Vladimir and the Greek princess Anne, daughter of Romanus II and sister of the emperors Basil and Constantine, whilst according to another belief, their father was Yaroslav the Holy and their mother a Bulgarian princess. Because of their royal rank they are always depicted wearing the garments reserved for princes, and in Russia the swords which they generally carry served as emblems of rank and princely authority. The brothers are usually dressed alike, but in clothes of alternating colours, though in this case Boris's cloak is lined with sable and Gleb's with rabbit fur or ermine.

The saints were worshipped in the cathedral of St Sophia at Constantinople from about the year 1200; their icon stood to the right of the altar, close to the spot where the Byzantine emperors were consecrated. In Novgorod, wooden churches were dedicated to them from the time of the country's conversion; the first Novgorodian chronicle mentions some under entries for the years 1146 and 1167. The saints were likewise worshipped in the Vladimir Suzdal district, and Kondakov links the paintings on which they are shown mounted with that region, whilst he ascribes the ones on which they appear standing to Novgorod. In Russia they symbolised brotherly love and devotion.

At a later date this panel was mounted in a wide border on which a late sixteenth-century artist painted sixteen small scenes illustrating the lives and martyrdoms of the two princes.

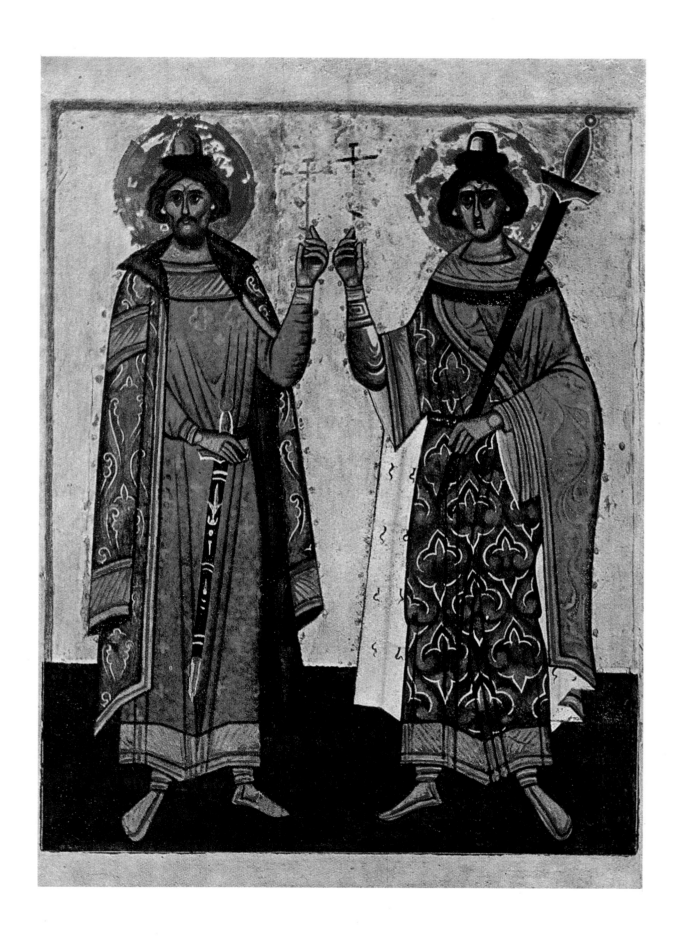

PLATE 21

A scene from the border of the icon of St Boris and St Gleb illustrated on the preceding plate

Painted in about 1590. Stroganov school, Moscow. Formerly in the Riabushinsky collection.

As has just been explained, the icon illustrated on the preceding plate was mounted late in the sixteenth century in a fairly wide frame or border decorated with sixteen small scenes, twelve of which portray incidents in the lives and martyrdoms of the two saints. In accordance with the second belief concerning their lineage, the four remaining scenes are devoted to the life of their younger brother, Yaroslav, the fourth son of Yaroslav the Holy, who ultimately succeeded his father and is known to history as Yaroslav the Wise. The incidents chosen for these scenes are concerned with the struggle for the throne waged by Yaroslav against the elder brother Sviatopolk, called the Damned, for causing the death of three of the brothers, namely of Boris, Gleb, and the youngest of the family, Sviatoslav. Yaroslav went to war to avenge these deaths, and although Sviatopolk enlisted the help of the King of Poland, the righteous brother prevailed.

The scene illustrated on this plate comes from the lower left-hand corner of the border. It shows Yaroslav standing in the door of his tent listening to a messenger announcing the death of Boris. Many realistic features are introduced into the scene, much of the clothing and equipment following contemporary lines. The painting, with its lavish use of gold, is in the best Stroganov manner; the treatment is extremely decorative, and although the scene is very small in size and very rich in detail, there is no feeling of overcrowding or confusion.

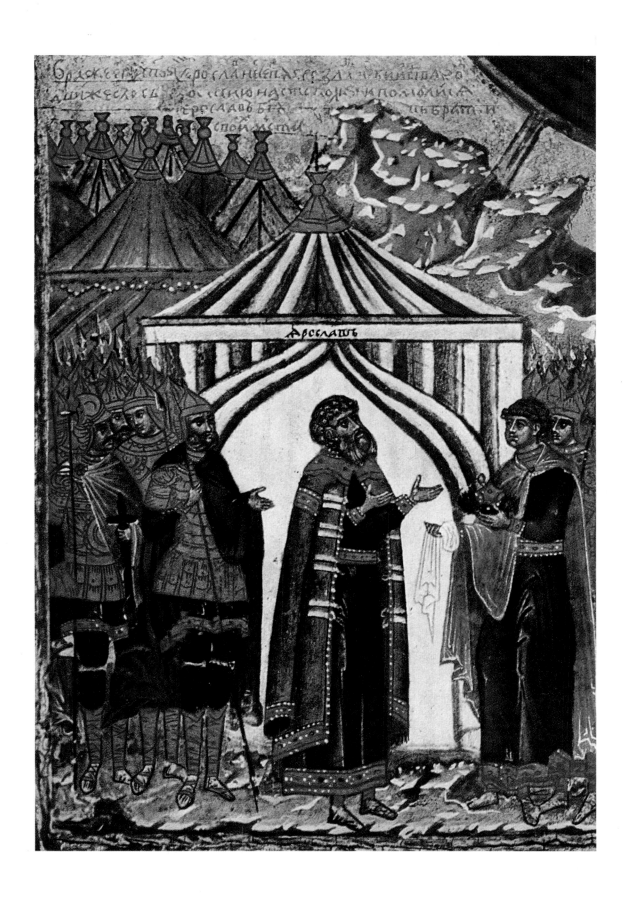

PLATE 22

A second scene drawn from the same border as that on plate 21

Painted in about 1590. Stroganov school, Moscow. Formerly in the Riabushinsky collection.

This extremely decorative battle scene appears on the lower rim of the border, coming next to the scene illustrated on the preceding plate. The painting is by the same hand as the last and is contemporary in date. The moment chosen for the icon shows the contest at its hottest, with the dead littering the foreground whilst the fight rages above and standards unfurl beyond. Once again the panel abounds with realistic details, and the men are shown with the shorter hair and round features of contemporary Muscovites. The Stroganov artists were very fond of using a great deal of gold in their paintings and much of it is evident in this panel, but, because of the very skilful manner in which white is introduced to offset it, it does not appear to excess. The rendering of the scene is somewhat suggestive of Persian miniature painting, and it is possible that the artist may have seen examples of Persian work.

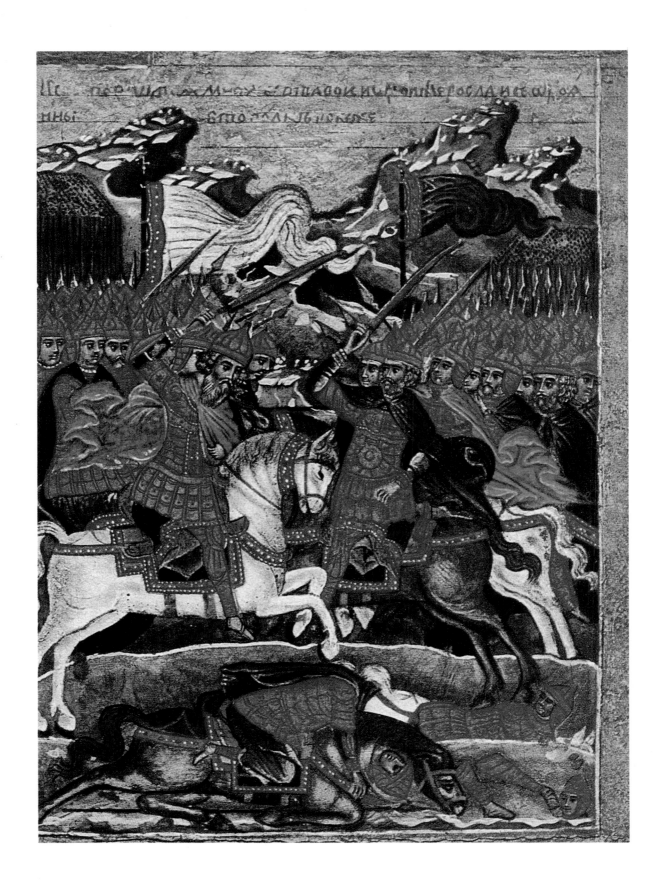

PLATE 23

Icon of St Florus and St Laurus

Last quarter of the fifteenth century. School of Novgorod. Formerly in the Ostroukhov collection, now in the Tretiakov Gallery, Moscow.

The saints were twin brothers. They were the object of particular veneration in the Balkans, a fact which present-day Russian scholars are inclined to ascribe to the survival there, well into Christian times, of the cult of the Dioscuri, which had been widespread in that area in antiquity. The iconography of the Christian form probably reached Novgorod from Bulgaria, and in Russia the saints were regarded from the start as the patrons of grooms and horses.

On this icon the saints are shown poised above their horses on either side of St Michael, who controls the riderless steeds by holding their bridles. In the centre appear the twin Cappadocian grooms, Eliseth and Eustace, thus seeming again to express the underlying duality of the icon; the third brother, Seth, rides behind. All three are occupied in guarding a herd of very naturalistically drawn horses. The inscription reads: 'The archangel Michael giving the care of the flocks to Florus and Laurus.'

The icon is in the best Novgorodian tradition.

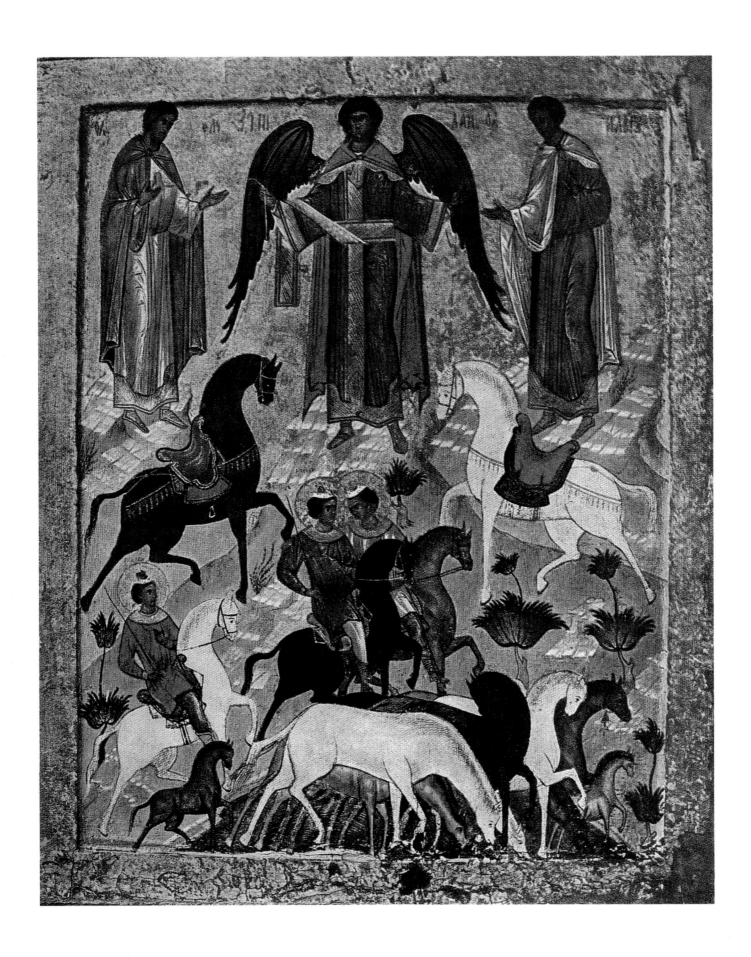

PLATE 24

Icon of St Nicholas of Myra

Second half of the fifteenth century. School of Moscow, following in the Novgorodian tradition. Formerly in the Ostroukhov collection.

This is an excellent example of a 'saintly' icon, showing the subject half length and with the features ascribed to him by tradition rendering him easily recognisable. Thus, though thin and elongated in accordance with the convention prevailing at that period, St Nicholas is shown as sturdy of build and, if no longer young, still very active. His head is oval in shape and his nose long in accordance with earlier traditions, but, nevertheless, his face is Russian in type; his beard is short and well groomed, his hair neat, falling in rhythmical waves; his expression is kindly, if a trifle severe. As was customary in Novgorodian painting, St Nicholas is shown on this icon wearing similar robes to those which appear in the miraculous icon venerated in the Cathedral of St Nicholas in-the-Court at Novgorod, whilst Muscovite icons usually conformed to the equally miraculous icon of St Nicholas of Zaryask, which was brought from Korsun in 1224, on which the saint is shown wearing a bishop's sakkos or robe. On the other hand the colouring of this icon, with its silver ground and predominance of blue, and the saint's Russian-looking face are characteristic of Muscovite painting.

The saint is shown here with medallions of the Saviour and the Virgin on either side of him. These small figures have the large heads which are typical of later fourteenth-century Novgorodian painting, but the icon is nevertheless hardly earlier than the middle of the fifteenth century.

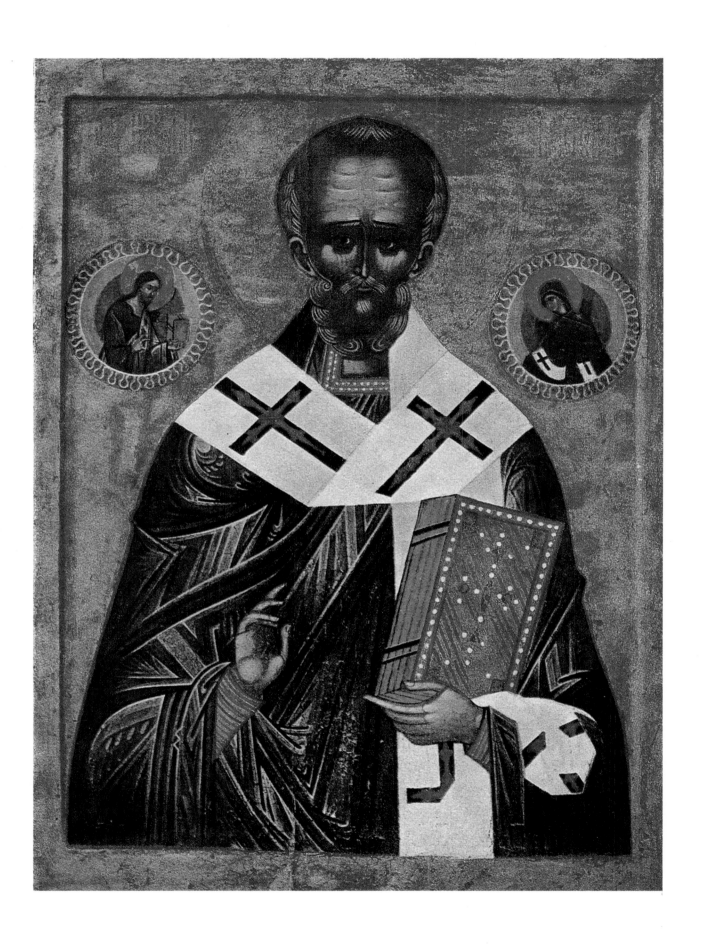

PLATE 25

Scene from the life of St Nicholas

A panel from a Royal Door. Early to mid-sixteenth century. School of Moscow. Formerly in the Riabushinsky collection.

This scene from the life of St Nicholas shows the saint's ordination as a deacon. Though the icon is of Muscovite workmanship, it adheres to Novgorodian traditions both in regard to the architectural forms of the church seen in the background and also in that of its colour scheme. On the other hand the small round heads and tiny hands and feet of the figures are characteristic of Moscow. The influence of Dionysius is reflected in the painter's preoccupation with composition; this expresses itself in a fondness for the recurring curve which is most effectively displayed in the inclined figure of St Nicholas; it is seen again in that of the officiating deacon and re-echoed anew in the curve formed by the scroll, which is held above the saint's inclined head.

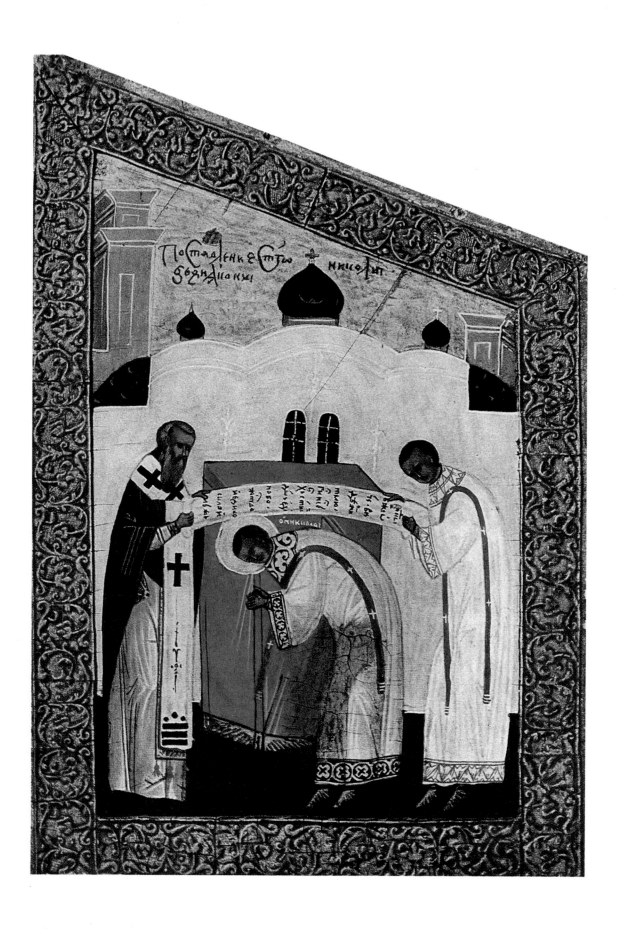

PLATE 26

Detail from an icon of St Nicholas illustrating scenes from his life

Sixteenth century. School of Novgorod. Formerly in the Ostroukhov collection.

At its establishment in the tenth century the Russian Orthodox Church was made dependent on the see of Ochrida, and fairly close links between Russia and the Balkans resulted. It is not, therefore, unusual to find points of resemblance between Russian and Balkan iconography, and the prototypes of Russian paintings showing scenes from the life of St Nicholas are to be sought in the Balkans rather than in Greece. In Novgorod paintings of this type became popular in the sixteenth century; the one illustrated on the accompanying plate shows the saint wearing a vestment adorned with black crosses of a type which does not appear in Russian iconography before the fifteenth century, and which is usual in paintings of the sixteenth century. St Nicholas was especially beloved in Novgorod, where he was regarded as the patron of carpenters, travellers and sufferers in general, and also as having the power to protect against fire.

This scene from his life illustrates the Miracle with the Polovtsian. According to legend a Polovtsian prisoner pined for his home; he had been baptised and prayed to St Nicholas for help, and, as a result, was released on parole. Back at home, however, he forgot his promise, and instead of returning to prison went out to plough his field. St Nicholas, deeply angered, appeared before him and administered a sound thrashing.

The style of the painting is a trifle archaic, the colours somewhat sombre, the outlines less clear than usual. A tendency towards realism is evident in the contemporary clothing worn by the Polovtsian as well as in the drawing of the horses and the heads of the personages which are rounder than in earlier Novgorodian painting; indeed, both trends reflect the influence of Moscow and point to the transitional period in Novgorodian painting.

PLATE 27

A second scene from the same icon as that illustrated on the preceding
plate

Sixteenth century. School of Novgorod. Formerly in the Ostroukhov collection.

Here St Nicholas is shown saving Demetrius from drowning. The swirling
waves and curved prow of the sinking boat reveal an innate and characteristi-
cally Russian feeling for design, and the painting may well be by another
hand than that responsible for the scene reproduced on the preceding plate.
Its treatment is a little less archaic, its execution a shade more accomplished,
and its composition more rhythmical than is the case in the last picture.

PLATE 28

Icon of St Luke the Evangelist

Late fifteenth century. School of Novgorod. The Tretiakov Gallery, Moscow.

This figure is shown in the pose rendered traditional by Byzantine manuscripts and is obviously derived from such a source. The Evangelist is seated in front of an elaborate architectural background of considerable realism. Furthermore, the stool on which he sits and that which he uses for his feet, as well as his desk and lectern, are all based on contemporary furniture designs. These factual details suggest a late date and Muscovite influence, but the elongated proportions of the Evangelist, his sloping shoulder and the curved line of his back, which is re-echoed in the shape of his head and the lines of his hair-dressing, are characteristic of the Rublev tradition. The elaborate treatment of the drapery is reminiscent of Dionysius, whilst the colour scheme remains essentially Novgorodian. The panel must be ascribed to an artist well acquainted with the main currents of contemporary Russian icon painting, who took from each school the elements which most appeared to him, fusing them all into a homogeneous and entirely successful work of art.

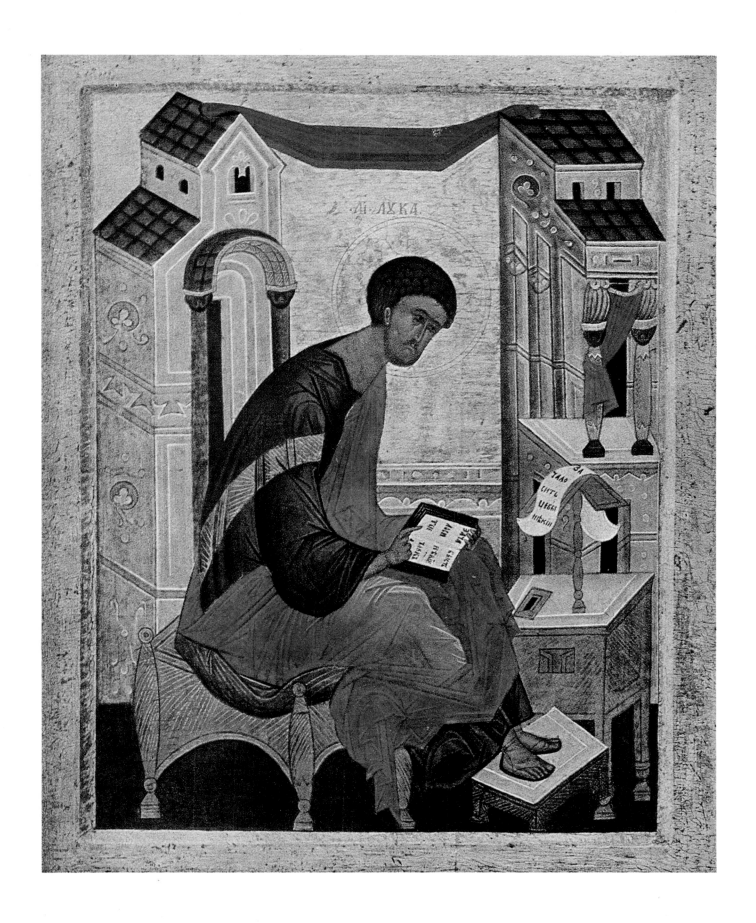

PLATE 29

Icon of St John the Theologian dictating his Epistle to Prochorus

Late fifteenth century. School of Novgorod. The Tretiakov Gallery, Moscow.

Like the last, this icon also closely follows the tradition of Byzantine manuscripts, but the heavy and at the same time essentially ascetic figure of the Evangelist reflects Serbian influence. His intensely dramatic gesture when struck by the ray of heavenly light and the elaborate drapery of his robe point to a follower of Dionysius, whilst the colouring, the elongation of the figures and the spirited treatment of the background are characteristic of Novgorod. There is no mistaking the very evident delight Russian icon painters took in depicting the great mountains with which they enlivened their backgrounds, yet the majority of the artists lived in completely flat country. Few of them can ever have seen real hills, and their conception of mountains must have been derived from the Byzantine paintings they had seen and the travellers' tales they had listened to. The rocks in this icon are particularly fantastic, the style of the painting being that of the transitional period in Novgorodian art.

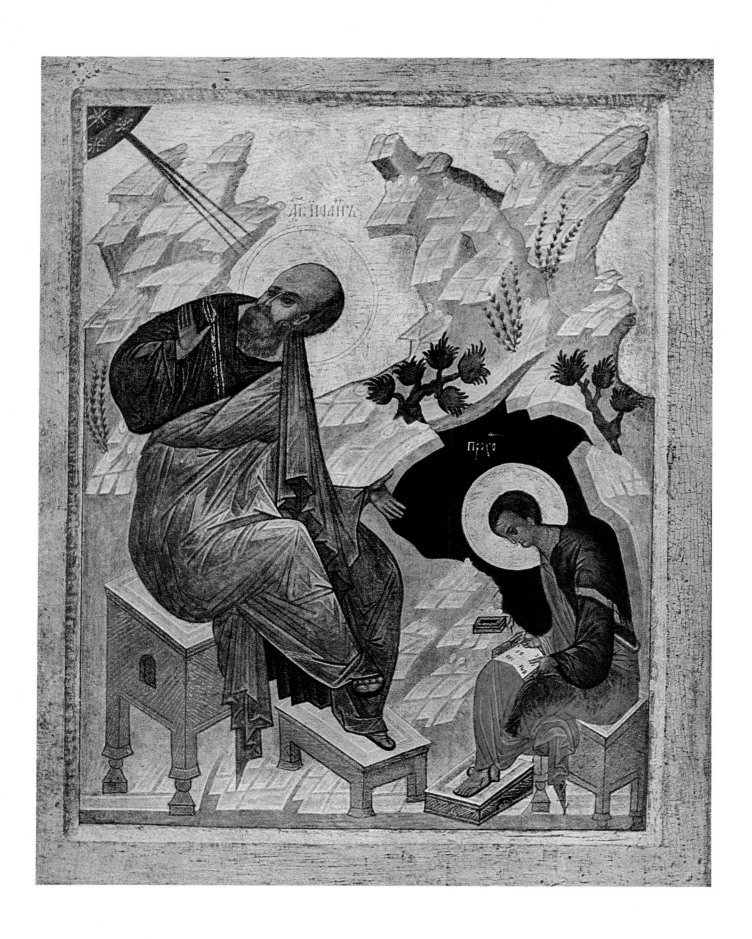

PLATES 30 to 35

The six sections from a 'Six Day' (Shestodnev) icon

First half of the sixteenth century. Transition period of the Novgorodian school. Formerly in the Ostroukhov collection.

The six day or one week cycle of events from the life of the Saviour is a very popular one in Russian iconography. It can either be represented on a single, composite icon or on six separate panels. The scenes reproduced on the six plates which follow are taken from a single icon consisting of nine scenes. The icon is divided horizontally into two halves, the lower one of which is filled with a great many figures representing the Orders of Saints, whilst the centre of the upper section depicts the Deesis amidst Choirs of Angels. A scene showing The Washing of the Feet appears on the left of this central composition, and that of the Crucifixion on the right of it. The remaining scenes are ranged along the upper register. They represent, looking from left to right: the Harrowing of Hell or the Anastasis; the Divine Forces; the Assembly of the Baptist and the Annunciation. Each is associated with a particular day of the week.

The icon is very close in style to the work of Dionysius, the elongation of the figures, the marked dramatic element and the impressionistic treatment of the rocks being strongly reminiscent of that master. The colours are also extremely good, but the drawing, notably of the Assembly of the Baptist (plate 32), reveals a less accomplished hand and the icon must be regarded as a workshop painting rather than a panel by Dionysius himself.

PLATE 30

Detail from a 'Six Day' Icon: The Harrowing of Hell

School of Novgorod. First half of the sixteenth century.

The Anastasis or the Harrowing of Hell is the Greek Orthodox rendering of the Resurrection. It depicts Christ's descent into Hell and the raising of Adam and Eve, and is particularly associated with Sunday worship. The subject is presented in a symmetrical arrangement, but the grouping is skilfully varied and monotony avoided. The hills, rising in fantastic crags in the background, are an integral part of the composition.

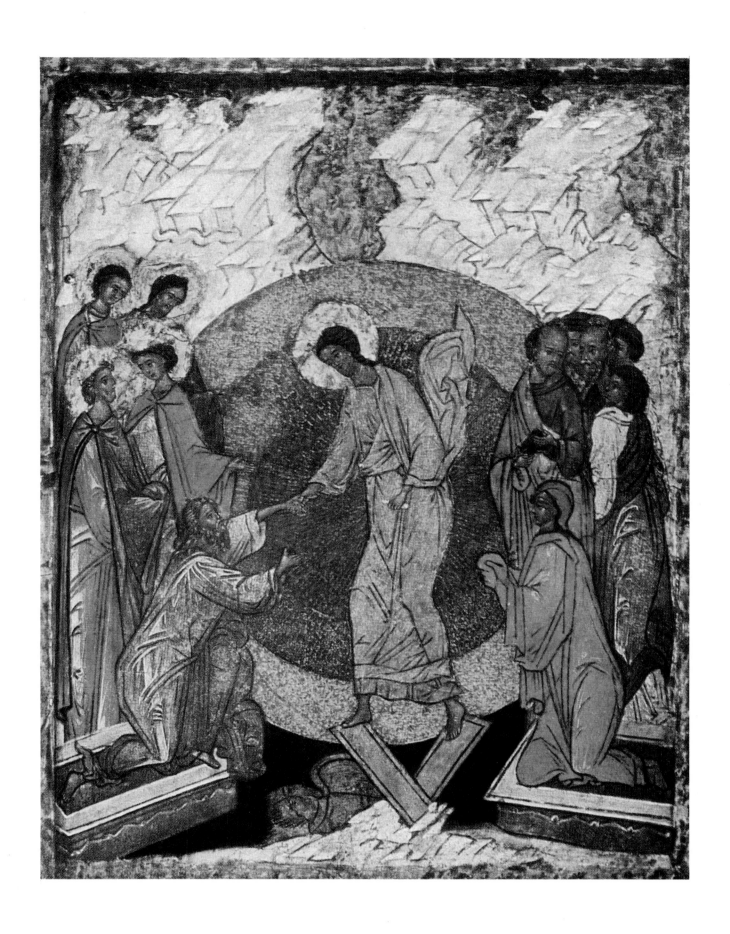

PLATE 31

Detail from a 'Six Day' Icon: The Divine Powers

School of Novgorod. First half of the sixteenth century.

The second scene in the icon's top register represents the Divine Powers and is linked with Monday. This is really an elaboration of the Choir of the Archangels (plate 8) with the difference that the medallion containing the Saviour Emmanuel, though still supported by the two archangels, is also placed between cherubim. The painting is in the fused manner whereby the faces are given only the most delicate of contour lines, very minute highlights being used, whilst other details, such as the upper cherubim, are painted first and their outlines added later. The colours are clear, varied and extremely harmonious, and the influence of Rublev can be discerned in the rhythmical grouping of the figures.

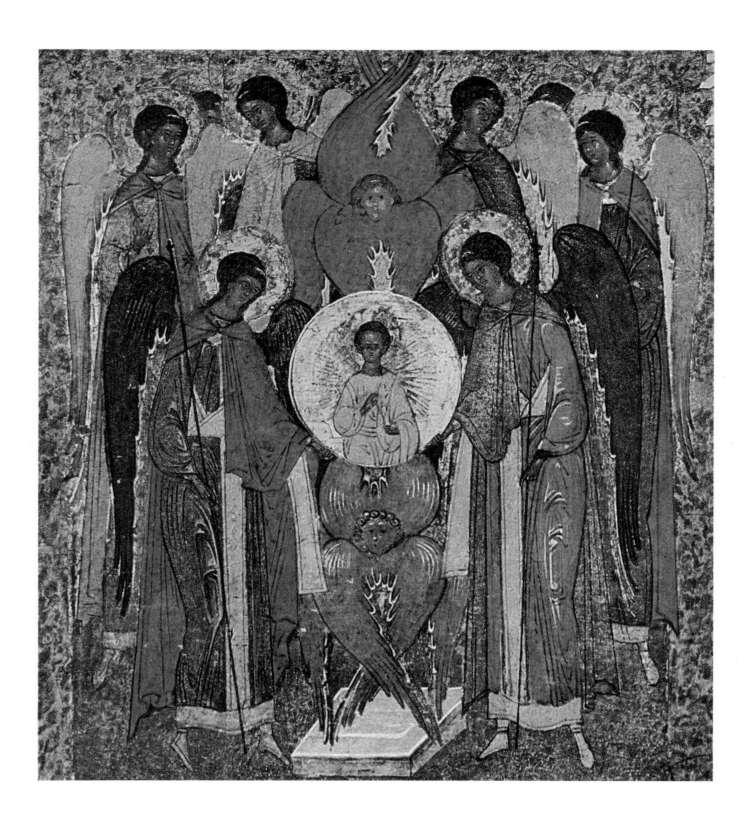

PLATE 32

Detail from a 'Six Day' Icon: The Assembly of the Baptist

School of Novgorod. First half of the sixteenth century.

The Assembly of the Baptist. This scene is a most unusual one, never seen in Byzantine and but seldom in Russian iconography. It is associated with Tuesday worship and appears to illustrate the passage in John III, 26, where it is written that disciples 'came to John and said unto him, He that was with you beyond Jordan, to whom thou bearest witness, behold the same baptiseth, and all men come to Him'.

Hills invariably play an important part in scenes of the Baptism, for they are meant to remind the worshippers of the steep cliffs of the Jordan, where the actual event took place. In this instance they are of particular interest because the artist has made a definite attempt to draw them in perspective. As a result the river does indeed look as if it is flowing between hills, and the group watching from the left bank really does appear to be standing in a valley. The realistic details introduced in the attire and the portrayal of the people gathered on both banks of the Jordan accord with the Muscovite spirit of the age.

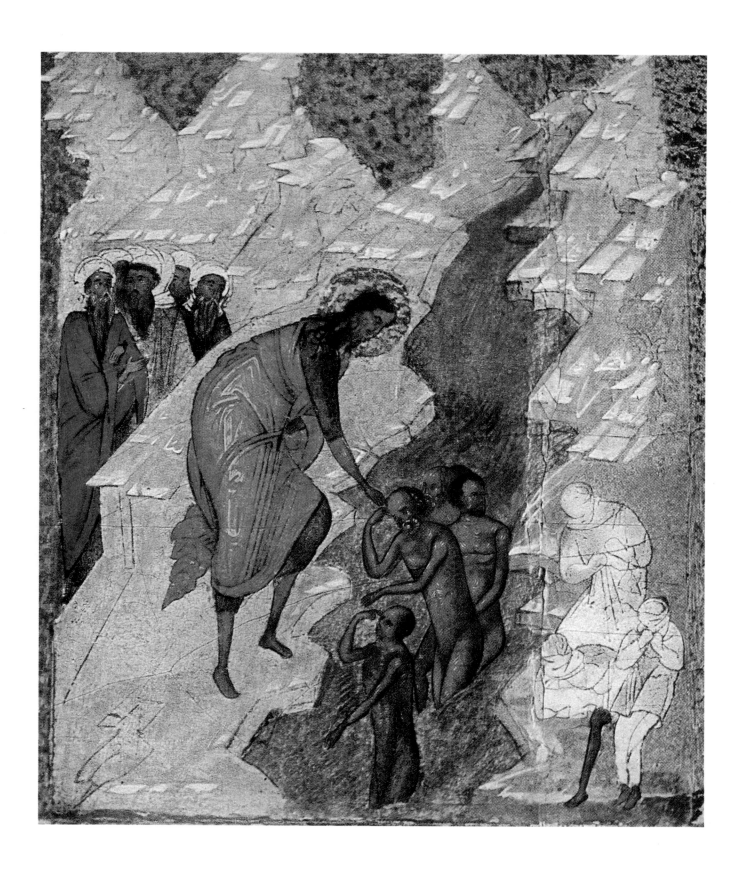

PLATE 33

Detail from a 'Six Day' Icon: The Annunciation

School of Novgorod. First half of the sixteenth century.

The Annunciation, Wednesday's icon, is the last scene in the icon's top register, occupying its right-hand corner. The realistic architectural background, consisting of a church surmounted by an onion-shaped dome erected over a high drum, an adjacent chapel and a detached bell tower, all of which are enclosed by a wall, has achieved a certain perspective, and reflects a feeling for spaces and planes that is new to Russian icon painting. The Virgin's throne and foot-stool conform to shapes which were current at the time, but the angel's right wing is raised in an unnatural, purely decorative manner, which is, however, characteristic of the period. The colours are good and typical of the age, but the drapery of the angel's robe is handled in a graphic rather than a sculptural manner.

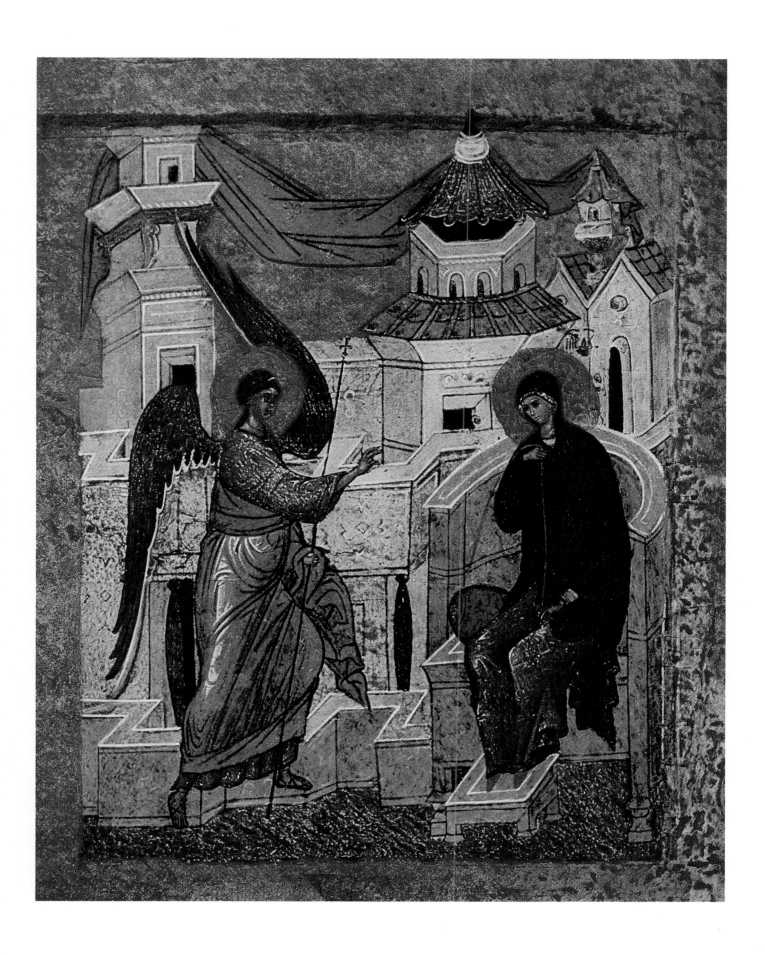

PLATE 34

Detail from a 'Six Day' Icon: The Washing of the Feet

First half of the sixteenth century.

The Washing of the Feet, the first, or left scene in the second register, appears for Thursday at the side of the central composition showing Emmanuel amidst Choirs of Angels. It is balanced on the opposite side of the icon by the Crucifixion, but neither this latter scene nor the central one is reproduced here. The Washing of the Feet comes closer to the work of Dionysius than do any of the other scenes illustrated on this icon, and if not by the master himself, then it must indeed have been painted by one of his closest followers. Its composition is extremely accomplished, for the artist solved the problem arising from the smallness of the space available for the scene by cleverly grouping his apostles on three different planes. The result is extremely effective, and overcrowding is avoided.

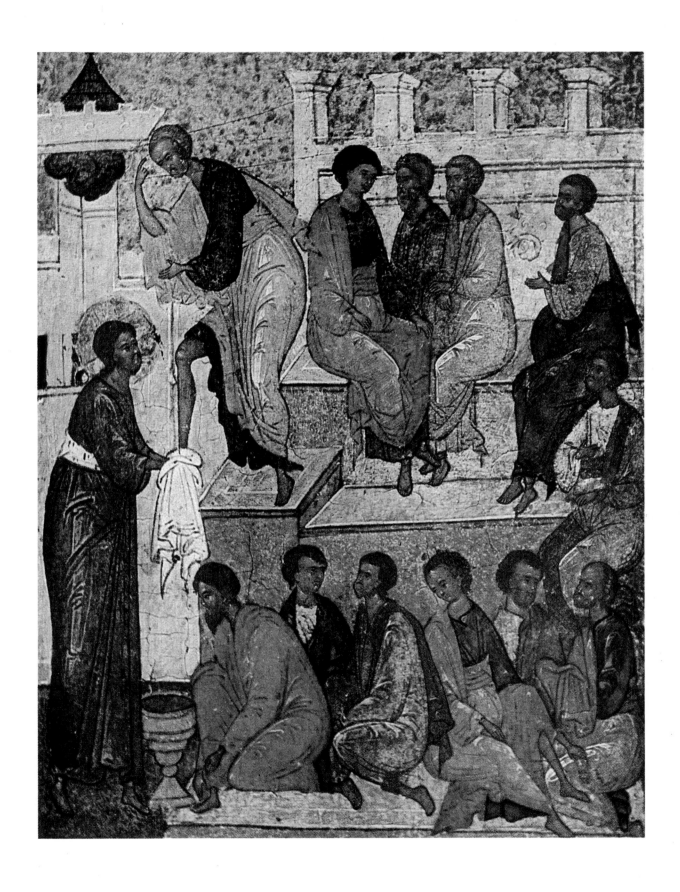

PLATE 35
Detail from a 'Six Day' Icon: The Body of Saints

First half of the sixteenth century.

The Body of Saints. The lower half of the icon contains two large groups of saints, each of which is further subdivided into five sections enclosed in oval-shaped compartments, each of which is backed with a different colour. Each compartment contains a particular group of divines. This plate illustrates the right-hand half of this scene, showing in the first, or left section of the lower register, a group of apostles; the next compartment contains the holy martyrs, and the last St Mary of Egypt and her companions. Above, the physicians of the church occupy the first compartment and some holy women the last. The white robes of these figures, appearing as they do against delicate, pastel-coloured grounds, provide the icon with an ethereal quality which plays no small part in balancing and blending the various sections of the painting into an aesthetic unity.

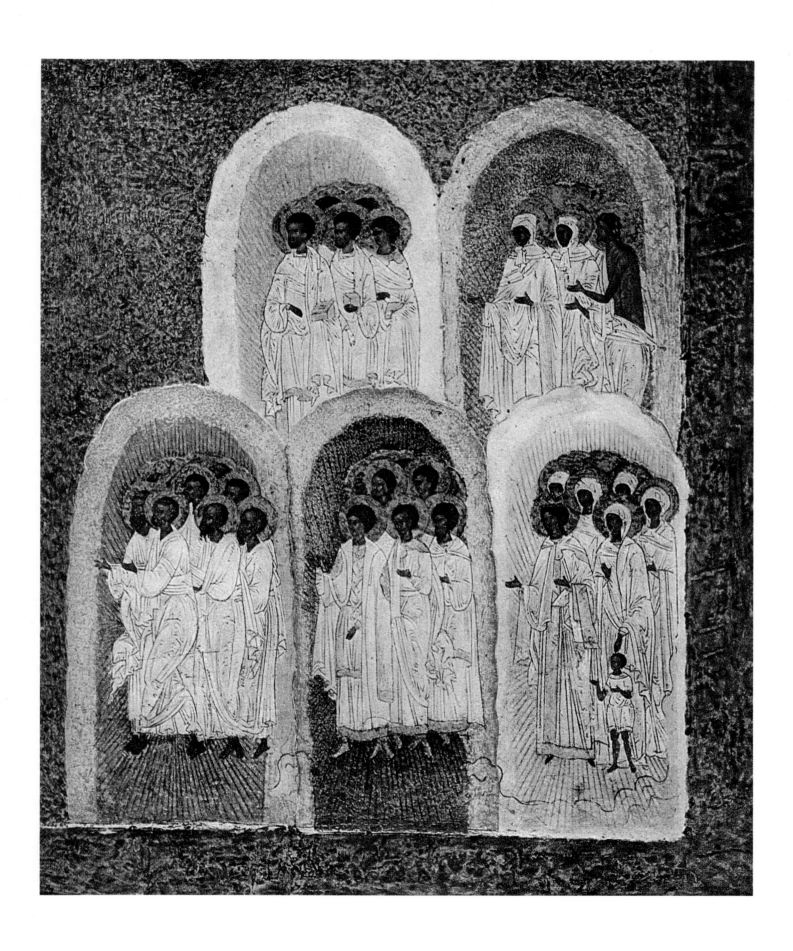

PLATE 36

Icon of the Entry into Jerusalem

Late fifteenth century. School of Moscow. Formerly in the Ostroukhov collection.

This icon follows the style of the Novgorodian transitional period. The old iconographic grouping is retained unaltered, but the city in the background is very realistic, incorporating many features belonging to Novgorodian architecture, whilst some of the figures issuing from its gates come very close to portraiture. The treatment of the hills is, on the other hand, wholly arbitrary, and the landscape is so subjected to decorative considerations that the palm tree is bent to conform to the rock's outline. The colours are still those which the Novgorodians loved, but the blacks and browns favoured by the painters of Moscow are also included.

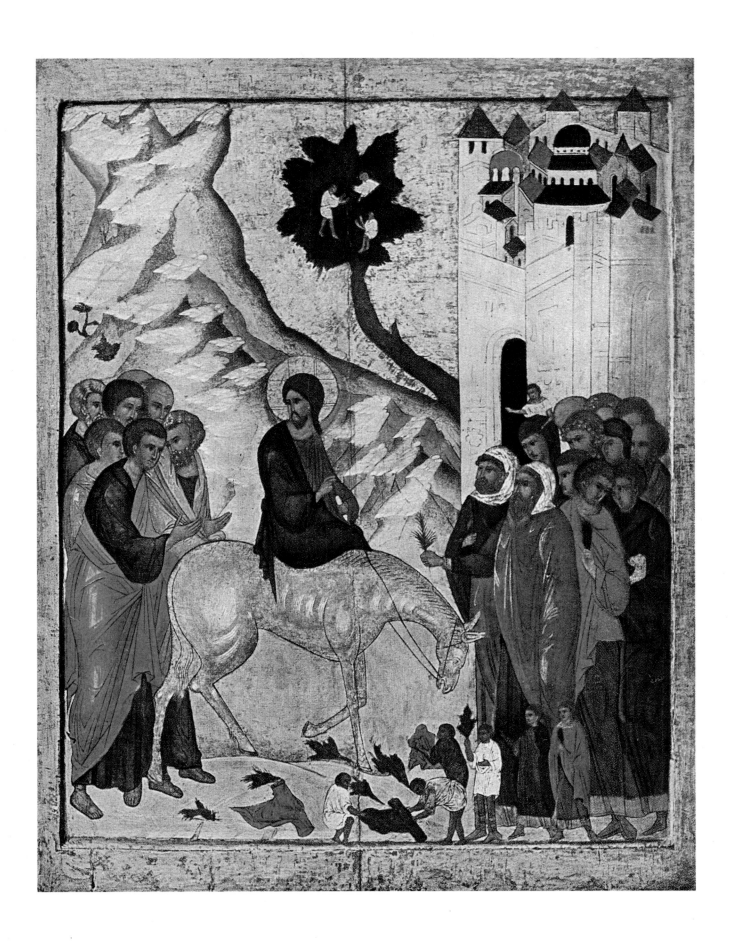

PLATE 37

Icon of the Crucifixion

Sixteenth century. School of Novgorod. The Russian Museum, Leningrad.

This is a magnificent icon of the transition period, closely resembling in style the mural paintings which Dionysius executed in the Therapont Monastery in Novgorod. It may well be by the hand of this master and must surely come from his workshop. The figures of the Virgin and St Mary Magdalene seem especially reminiscent of his work. Again we have here the elongated proportions, the saint poised on tip-toe, the deep drama of the scene and the essentially realistic architectural background which Dionysius combined into splendid, deeply moving pictures. The colours of this icon are less typical of Novgorod than of Moscow, and point once again to the influence of Dionysius.

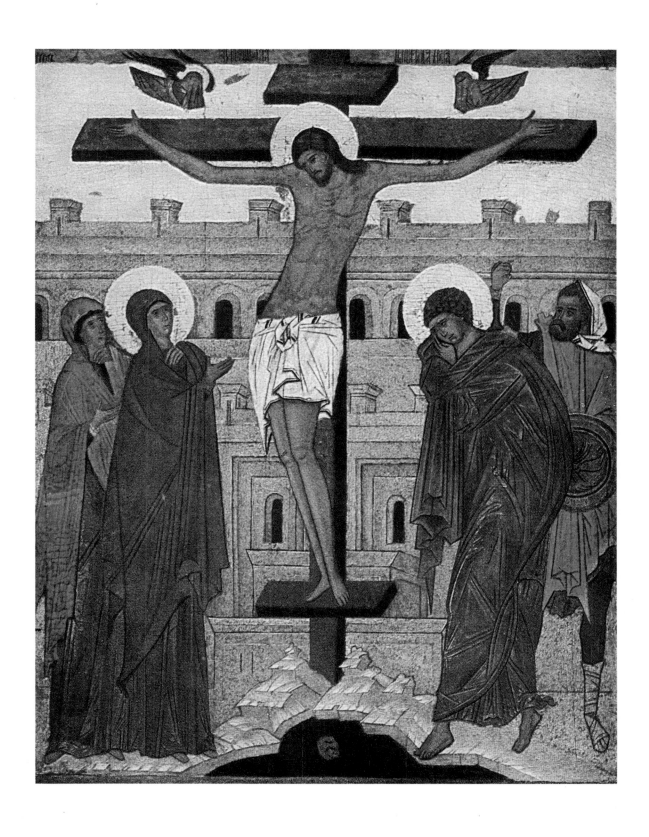

PLATE 38

Icon of the Descent from the Cross

Late fifteenth century. Northern school. Formerly in the Ostroukhov collection, now in the Tretiakov Gallery, Moscow.

The moment recorded here is the one when the Virgin, Joseph, Nicodemus and St John receive the Saviour's body from the cross, whilst Mary Magdalene and Mary of Egypt grieve at their sides. At first glance the painting seems to fall into the Novgorodian group, but closer examination quickly shows that this is not so, and the panel is now assigned to a region lying to the north of Novgorod.

The style of the icon, notably the elongation of the figures, the small heads and extremities, the anatomical details of the Saviour's body and the period features in the building forming the background, are definitely those of the late fifteenth century, but the simplicity of the presentation and the absence of all unnecessary detail recall an earlier age. The painter was obviously not interested in extraneous features, and the building, though contemporary in outline, is treated in a perfunctory manner. The artist's attention was concentrated on the human figures and the drama of the enacted scene, and he followed the candid manner of presentation characteristic of an earlier age in order to create an immediate impact. He was at the same time an excellent master of composition, quick to stress the harsh horizontal lines of the cross by means of the building stretching beneath it, intensifying the effect by introducing the slanting line provided by the improbably poised ladder. Most striking, however, is the peculiarly sensitive feeling for linear rhythm which, together with his very delicate use of the curved line, imbue the painting with a character entirely its own.

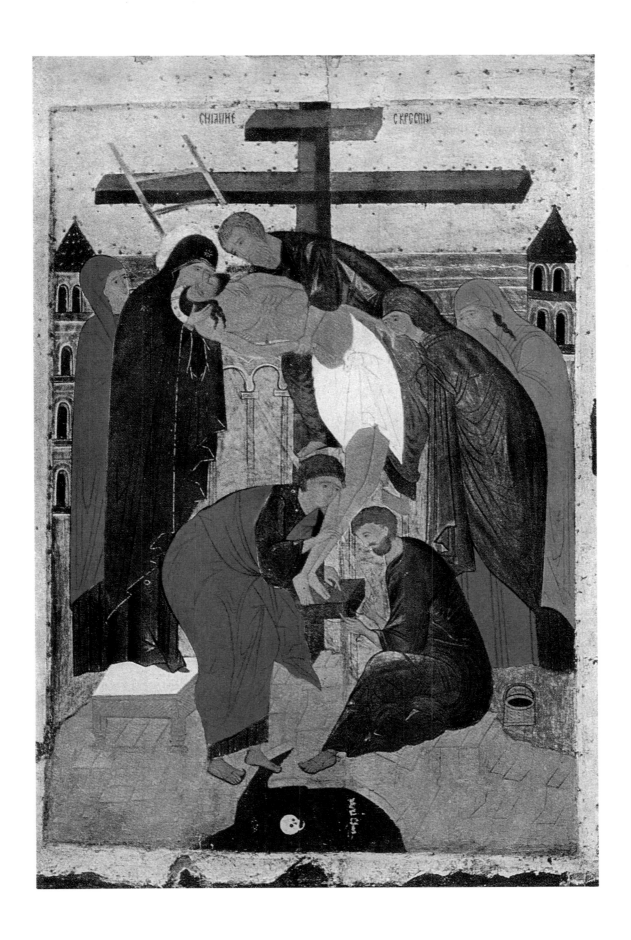

PLATE 39

Icon of the Laying in the Bier or Lamentation

A painting of the same date and by the same hand as the icon on the preceding plate. Formerly in the Ostroukhov collection, now in the Tretiakov Gallery, Moscow.

The same personages are represented on this icon as on the last, and the artist's fascination with the curved line is expressed even more clearly than it was in the icon showing the descent from the Cross. Thus, the curve of the Virgin's lamenting figure is repeated at a slightly higher point by that of St John, to be stressed anew, again at a somewhat higher level, by that of Joseph. Real artistry dictated the upright position of Mary Magdalene, though the curve occurs in the fall of her robe and the rounded shape of her shoulder and head, re-echo with the utmost felicity in the bent heads of the remaining figures. Indeed, the dramatic element is perhaps even more strongly marked in this painting than it was in the last, for the women's faces express greater depth of feeling. The artist's lack of interest in landscape is again very evident in this panel, where the hills are treated so schematically that they have lost all semblance of reality, recalling a series of tiny chapels or abstract geometric forms rather than an outcrop of rocks.

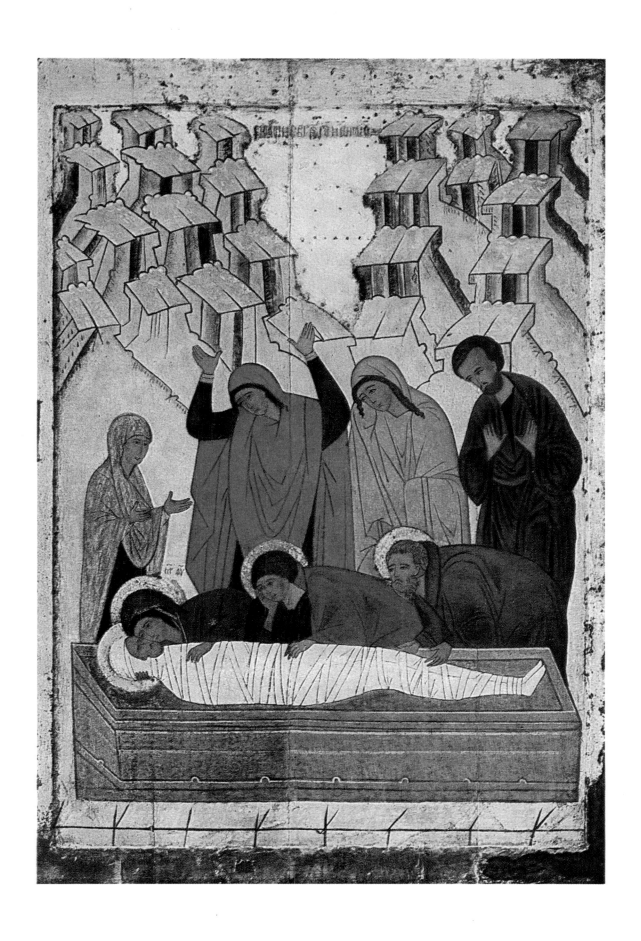

PLATES 40 to 43

Details from a travelling or field iconostasis

Late fifteenth century. Early Moscow school. Formerly in the Riabushinsky collection.

With the liberation of Russia from the Mongol yoke and the integration of the country under Muscovite rule, travel became possible for many more people, and small, portable iconostasis began to be made both for travellers and for the new class of well-to-do army officers. These iconostasis filled very much the same need as that satisfied by the prayer carpet in the Islamic world.

The iconostasis discussed below is not illustrated here in its entirety, only the lower half of its three panels and the top figure of the right-hand panel being reproduced on the four plates which follow. The three figures of the lower register form the Deesis group when seen in conjunction with each other.

PLATE 40

Detail from a Travelling Iconostasis: The Virgin

School of Moscow. Late fifteenth century.

The Virgin occupies the lower register of the left panel. She stands on a band of green against a gold background, wearing the red slippers reserved for persons of rank and the dark-coloured robes beloved by the artists of Moscow. In the original, the middle register of this panel displays the Baptism, and the figure of King David appears above.

95

PLATE 41

Detail from a Travelling Iconostasis: The Saviour

School of Moscow. Late fifteenth century.

The lower half of the central panel of the iconostasis displays the Saviour seated in majesty. The colours are severe and impressive, the contrasting reds and touches of black, brown and white being especially characteristic of the period. The treatment is simple yet grand, and if the Saviour's face is a little lacking in depth of feeling, the figure is nevertheless dignified and aesthetically convincing. The throne, with burning torches set at its angles, is treated architecturally, its tentative perspective succeeding in giving some idea of its great depth.

The upper half of the panel is divided into two tiers, the lower showing the Transfiguration and the Raising of Lazarus, the upper the Old Testament Trinity and the Virgin and Child.

PLATE 42

Detail from a Travelling Iconostasis: St John the Baptist

School of Moscow. Late fifteenth century.

The lower half of the right-hand panel presents St John, thereby completing the Deesis group. St John is clothed in a hermit's garb, his wrap being used to great decorative advantage.

The Entry into Jerusalem appears above the figure of St John, and a painting of the prophet Solomon, filling the top tier, completes the iconostasis.

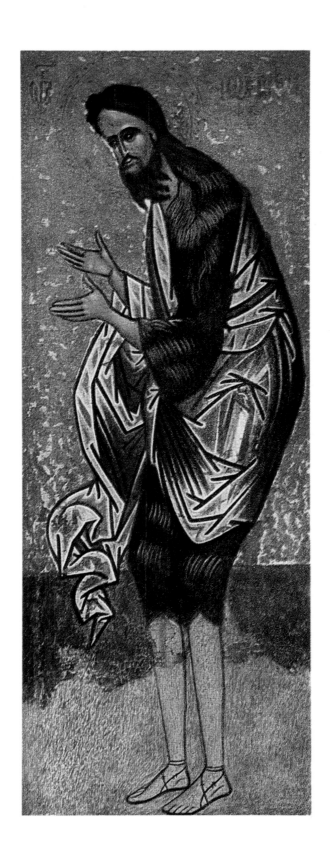

PLATE 43

Detail from a Travelling Iconostasis: The Prophet Solomon

School of Moscow. Late fifteenth century.

The Prophet Solomon, from the top tier of the right-hand panel of the same miniature iconostasis.

This figure is in a completely different style from the Deesis group, showing far greater affinity with the old merchant republic of Novgorod than with the sophisticated capital. The prophet is presented in the simple, candid manner of an earlier age, and when it is realised that the entire scene measures little more than five inches in height, the monumental character of the painting becomes apparent. The work is very obviously by a different hand from that responsible for the Deesis group. There is nothing unusual in two people engaged on a single icon, for artists often combined, the one painting the bodies and general contours whilst another executed the faces and hands, or one providing the background and another the scene.

The figure of Solomon is painted in accordance with the old Novgorodian tradition, the highlights on his face being formed by parallel lines, his hair being carefully arranged in rhythmical coils and his shoulders sloped in the way beloved by the early masters. On the other hand, the shape of his crown closely resembles that worn by a figure appearing on the wall paintings executed in the Cathedral of the annunciation in Moscow at the close of the fifteenth century, and thus bears out the later dating.

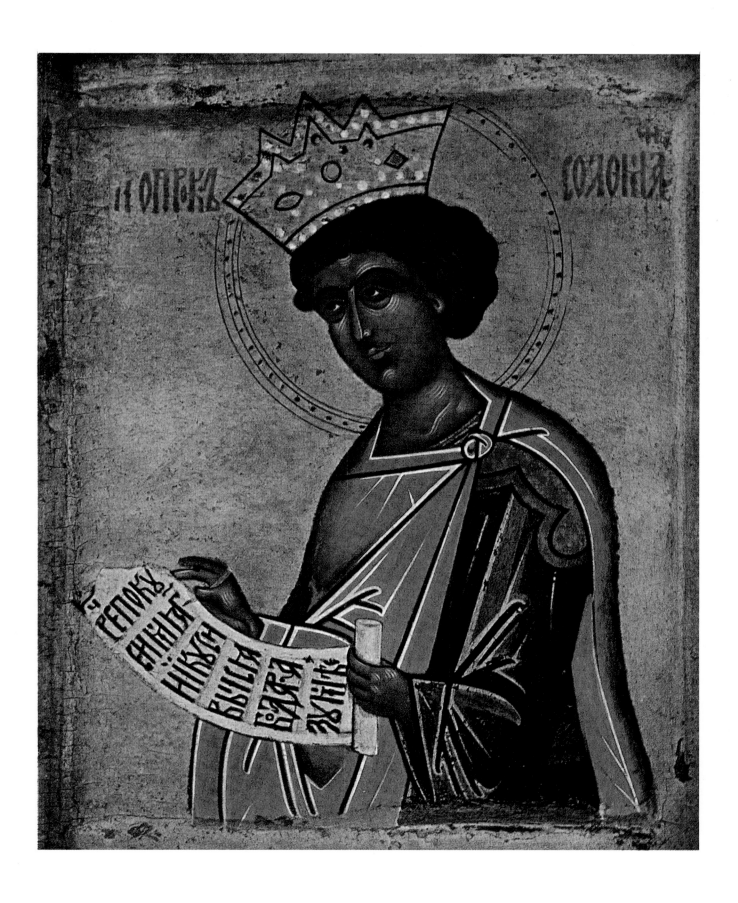

PLATE 44

The Annunciation

Middle to late sixteenth century. School of Moscow. The Russian Museum, Leningrad.

This scene is in two parts, for it forms the upper section of a pair of Royal Doors from an iconostasis. Comparison with the painting of the same scene illustrated on plate 33 shows how greatly the style had altered in Moscow within a very few years. Thus, although the iconography is unchanged and the angel's wing continues to rise in the same curious, essentially decorative line, the figures have become stockier and more earthly, the colours have darkened, and a profusion of gold hatching has been introduced to enliven the sombre shades. The architecture, though no less realistic, has become infinitely more baroque and fantastic. Something of the deep emotion of the earlier years has been lost, but this is not wholly due to the lapse of time; part of the loss must in all fairness be ascribed to the painter's lesser skill, a touch of clumsiness marring his rendering of the Virgin.

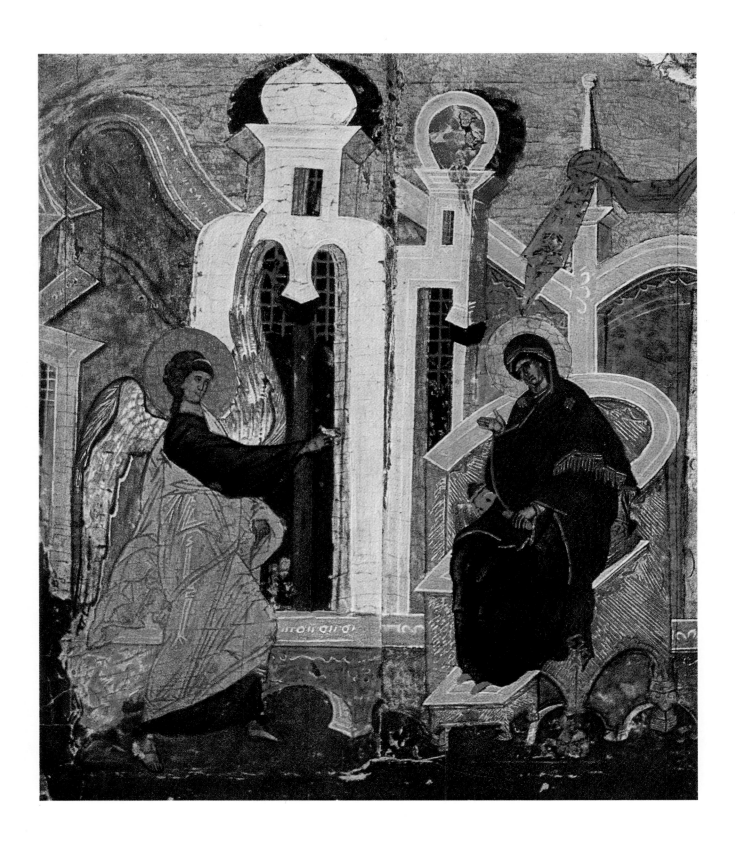

PLATE 45

Icon of the Dormition

Sixteenth century. Late Novgorodian tradition, but probably by an artist of the school of Moscow.
Formerly in the Ostroukhov collection.

This icon was intended for the Festival tier of an iconostasis. It depicts an elaborate version of the Dormition, which is iconographically related to some thirteenth- and fourteenth-century mural paintings of this scene that appear in certain Yugoslav churches. The Virgin lies in her bier in the foreground of the composition, whilst Christ, holding her soul, which is represented in the form of a tiny child, stands in an aureole. Angels, archangels and cherubim look down upon Him; on either side apostles, fathers of the church and holy men and women stream from two chapels of Novgorodian shape, to gather round the bier, and the Jew Amphonius ventures to approach, to touch it, but an avenging angel severs his hands before he can do so. The souls of the twelve apostles watch from heaven and, above, the Virgin, supported before a mandorla by two angels, also contemplates the scene.

The human proportions of the figures are elongated in this painting in accordance with Novgorodian custom, but the artist's evident interest in composition is reflected in the grouping, dramatic poses and inclined movements of the figures. The draperies are elaborately worked, but the colours are darker and dimmer than at the time of Novgorod's ascendancy, and the use of much gold and the trend towards realism, which is reflected in the shapes of the side chapels, where attempts at perspective are also to be observed, point to Muscovite influence.

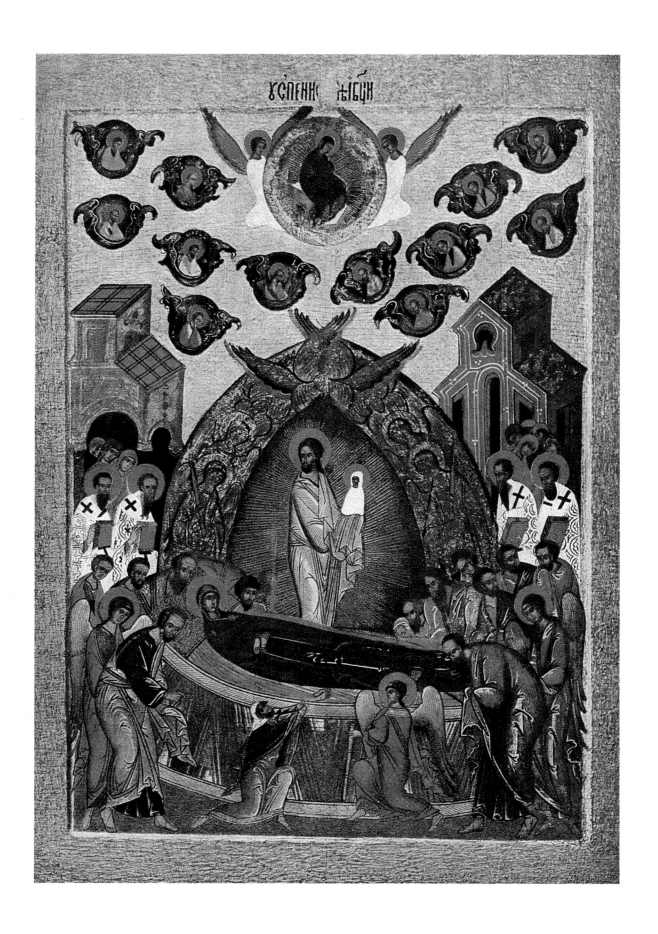

PLATE 46

Icon of the Deesis

Early sixteenth century. Transitional period of Novgorodian painting. Formerly in the Ostroukhov collection.

Here the figures forming the basic Deesis group are shown full length on a single panel, the Saviour being presented enthroned. Their elongated proportions accord with the Novgorodian style, but their slightly formal and conventional expressions, when considered in conjunction with the dramatic poses of their hands and the artist's obviously conscious striving after decorative effect, are elements which point to a follower of Dionysius as the painter of this icon. The panel is notable for its grandeur of its grouping and spacing, the elegance and sureness of the drawing and the delicacy and depth of its subtle colours, which are particularly beautiful. The icon is difficult to place, for it does not fall into any specific group. The artist was working well within the established tradition, but he followed his own particular bent.

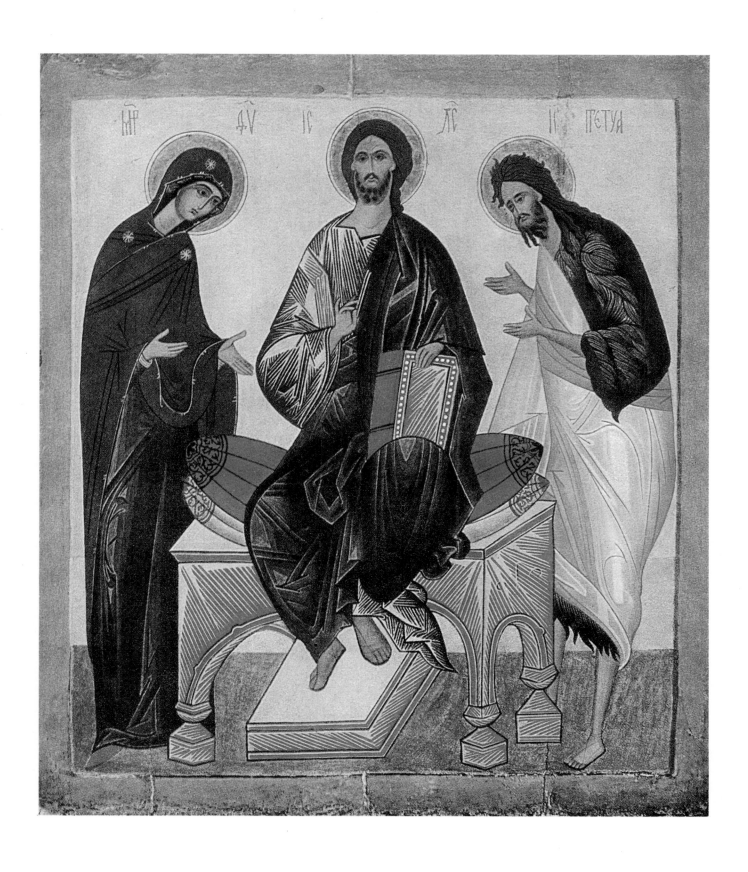

A travelling or field iconstasis in the form of a triptych

Late fifteenth, early sixteenth century. School of Moscow. The Tretiakov Gallery, Moscow.

This fine Muscovite icon closely follows the Novgorodian tradition. When fully opened out, the lower register corresponds to the Deesis tier of an iconostasis, the second to that of the Festival row, and the upper to the row in which the prophets and the fathers of the church are shown. In each panel the gold of the background is badly worn, revealing the gesso.

The Deesis register, and that showing the prophets and other saintly personages approaching the enthroned Virgin and Child, are painted in the grand, restrained colours favoured by Moscow for the presentation of such august subjects. The style and treatment of these sections of the painting bear a marked resemblance to those of the Deesis illustrated on plates 40–43, and, in both, the principal figures are shown standing on a green ground. The browner tones of the grounds seen on the upper and lower tiers of the right hand panel of the icon illustrated here, as well as in the lower register of the left panel, are probably due to dirt and subsequent over-painting.

It is interesting to note that both in the Deesis reproduced here and in the one illustrated on plates 40–43 the subsidiary scenes are handled in a different manner from the main ones, being closer in sympathy with the more intimate Novgorodian manner than with the more formal style of the capital. It might well be said that the Novgorodian treatment is epic, whereas that of Moscow is imperial. In this miniature iconostasis the Festival register – showing, when looking from left to right, the Annunciation, the Nativity, the Presentation in the Temple, the Baptism, the Raising of Lazarus, the Entry into Jerusalem, the Crucifixion, the Harrowing of Hell (the Resurrection), Thomas's Unbelief, the Ascension, the Old Testament Trinity and the Virgin's Dormition – keeps very closely to the Novgorodian tradition, even to the use of the bright pinks and lemon yellow which are so distinctive a feature of this school.

PLATE 47

Travelling or Field Iconostasis: Left panel

School of Moscow. Late fifteenth, early sixteenth century.

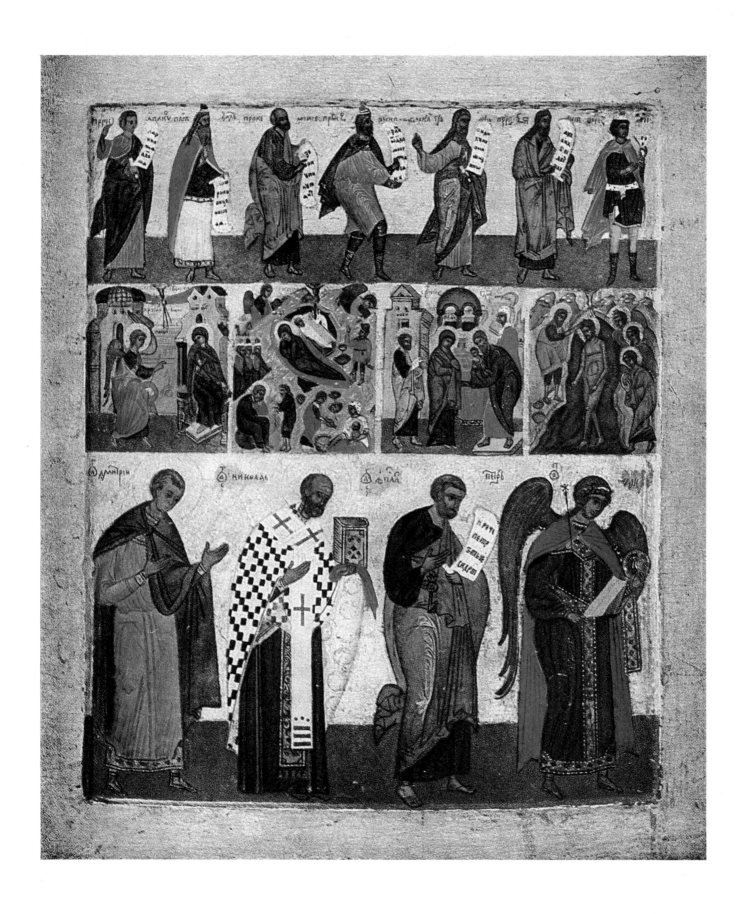

PLATE 48

Travelling or Field Iconostasis: Centre panel

School of Moscow. Late fifteenth, early sixteenth century.

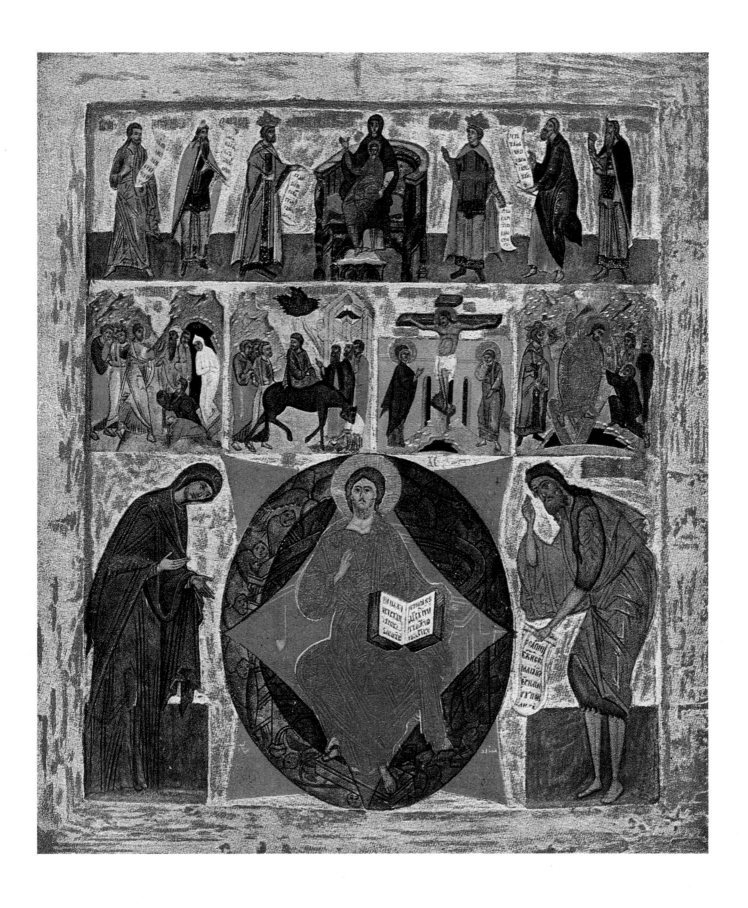

PLATE 49
Travelling or Field Iconostasis: Right panel

School of Moscow. Late 15th, early 16th century.

School of Moscow. Late 15th, early 16th century.

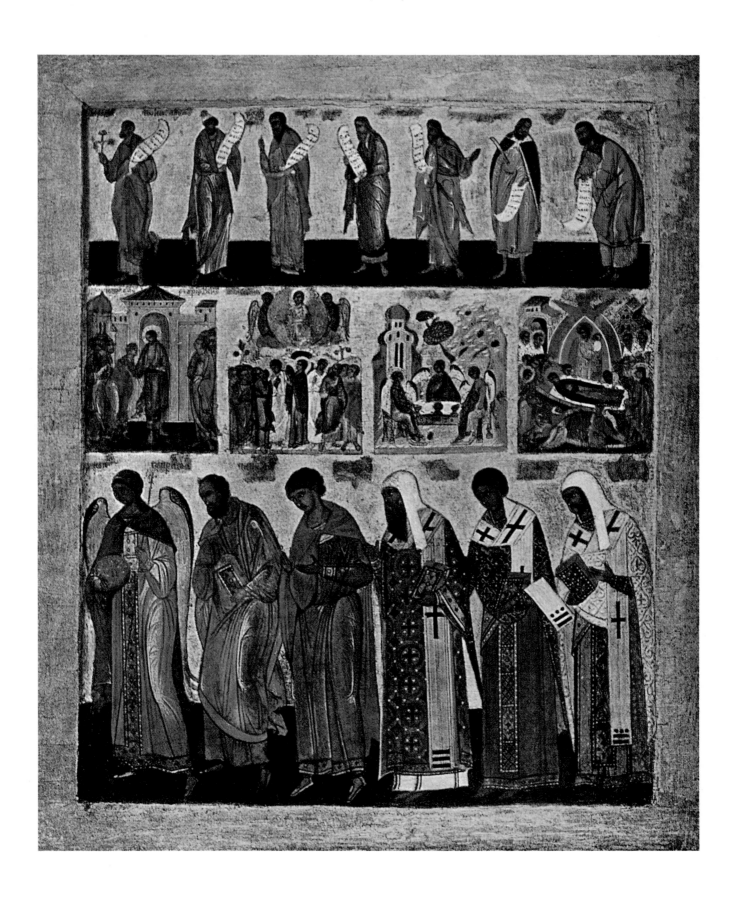

PLATE 50

Icon of the Nativity

Sixteenth century. In the mixed manner of the Novgorodian–Muscovite school. Formerly in the Ostroukhov collection.

It is interesting to compare this icon with the earlier version illustrated on Plate 16. In both cases the manger, with the Child in it and the ass and ox on either side, still stands in the door of the uncovered cave, which continues to be shown as a cleft in the mountains. The Virgin retains her prescribed pose and place in the centre of the painting, the angels who imparted the good news to the shepherds appear as before in the top register; beneath them, the three kings approach as usual from the left, whilst, on the right, a shepherd listens to the good tidings. Below there is a slight deviation, for an attendant brings the news to Joseph in place of the shepherd, who is shown guarding his flock in the distance; but, as before, other attendants are occupied in bathing the Child.

The difference between the two versions is apparent in the style of the painting rather than in their iconography. Thus, though the composition of the later work is finely balanced as ever, its colours have already lost something of the brilliance and subtlety which mark the Novgorodian paintings. The Virgin's pose, as she reclines with a leg elegantly crossed, is slightly mannered, whilst the fingers surrounding her are a little stumpy and inelegant. These shortcomings are pointers, however slight, of the ultimate deterioration of the art, but in this instance they are still so very faint that the icon remains one of really high quality. Its delicate enamelled border and haloes are excellent examples of the fine metalwork of the period. The icon is one of a series which admirably illustrates the transfer of some Novgorodian workshops to Moscow, where the artists came in contact with examples of Suzdalian painting and, by fusing the latter style to their own, laid the foundations of the Muscovite school of painting.

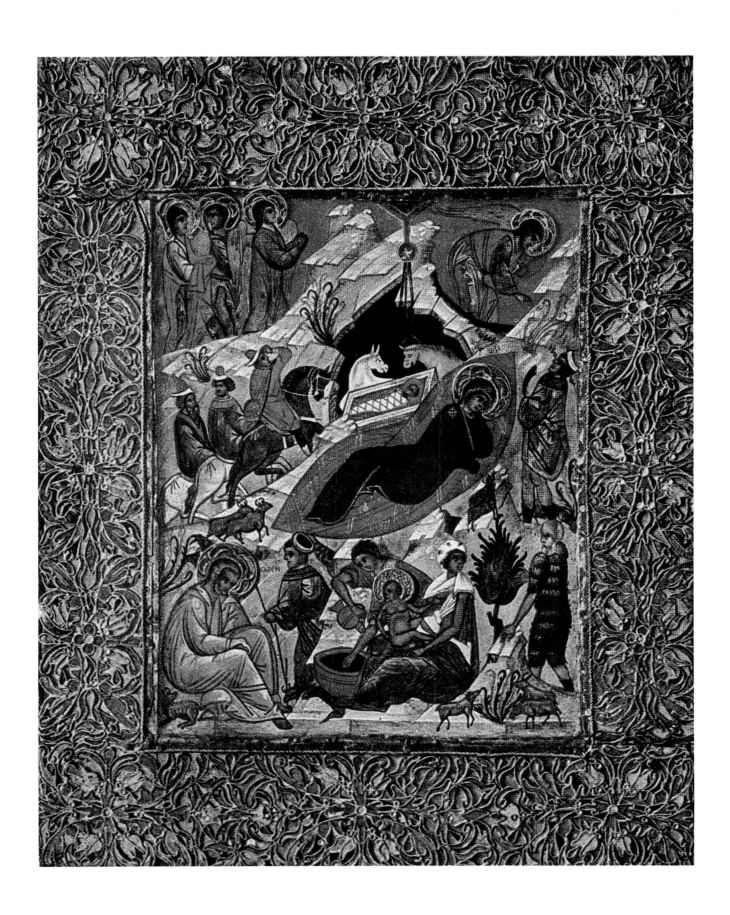

115

PLATE 51

Icon of the Entry into Jerusalem

Middle to late sixteenth century. School of Moscow. Formerly in the Ostroukhov collection.

This is a characteristic icon of its school and period. Once again comparison with an earlier version of the same subject, that illustrated on plate 36, serves to show how greatly the style altered in the course of only a few decades. In this later work the Novgorodian colours have given way to the love of sombre, magnificent shades and the profusion of gold and ochre tones favoured by Moscow. The iconography differs in one important detail, whereby the Saviour, though still riding His donkey sideways, is shown with His legs facing the worshippers. This is far from being an improvement from the aesthetic point of view, for it renders His pose clumsy as He turns to glance at the apostles. The latter are treated far more dramatically than in the earlier version, and there is a more obvious striving, if not at portraiture, then, at any rate, at variety of pose and expression, with the result that the group is more lively, though less stately than in the Novgorodian icon. The citizens of Jerusalem, grouped on the right of the panel, are handled with complete naturalism, some of the faces approaching very close to portraiture. The realism is further emphasised by the inclusion of contemporary items of costume and of the baroque architectural outlines which were so much in fashion in Moscow of that time. The drawing heralds the style of the Stroganov school.

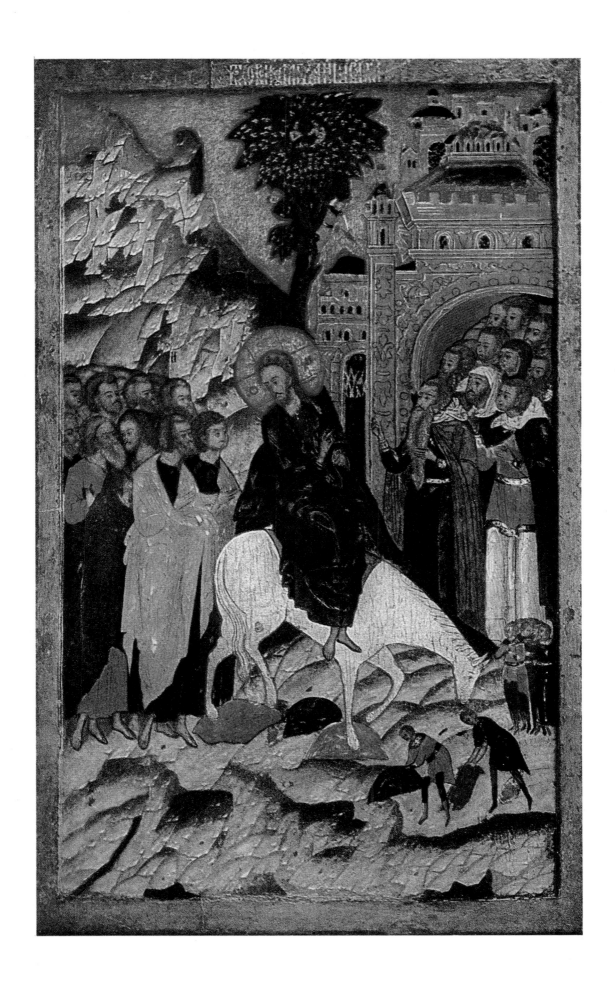

PLATE 52

Royal Doors from an iconostasis

Sixteenth century. School of Moscow. The Tretiakov Gallery, Moscow.

The central doors of an iconostasis give access to the apse containing the altar and, in consequence, are known as the Royal Doors. With the introduction of the elaborate inconostasis, the custom grew up in the fourteenth century of transferring the traditional biblical scenes from the walls on which the artists had been in the habit of painting them to the icons placed on the iconostasis: it then became usual for the pictures of the evangelists, which had formerly appeared in the squinches or pendentives of the dome, to occupy the lower panels of the Royal Doors, whilst the Annunciation or the Eucharist generally appeared above them. In this instance, though the Annunciation remains in its traditional place, the figures of St Basil the Great and St John Chrysostom have replaced the evangelists on the lower panels of the doors; it is probable from this that the doors were made for a church dedicated to these two saints.

PLATE 53

Icon of St George rescuing the princess

Early sixteenth century. School of Novgorod, transitional period. Formerly in the Ostroukhov collection.

The story of St George and the princess is a very ancient one, for although it was not recorded in writing till the tenth or eleventh century, it was already extremely well known in the Emperor Justinian's days. It reached Russia in the eleventh century, when the cult of St George became widespread there, largely as the result of the founding in 1030 by Prince Yaroslav Vladimirovich of a monastery at Uriev, to mark a victory he had won over the Mongols. He dedicated the monastery's church to St George.

The inscription on this icon reads: 'St George the Brave saved a city from a serpent named Laoseya and the king's daughter from being devoured by a serpent named . . . aya.' St George no longer appears alone here as he did on the icons illustrated on plates 18 and 19; he is welcomed at the gates of the city by the princess, who holds the leash of the vanquished dragon, whilst her parents watch from a battlement and a citizen looks on from a rampart. St George is shown against a pale blue ground, and Kondakov was inclined to think that this version of the scene was derived from an Italian picture painted in Hungary for King Matthias Corvinus, who reigned there from 1456 to 1490.

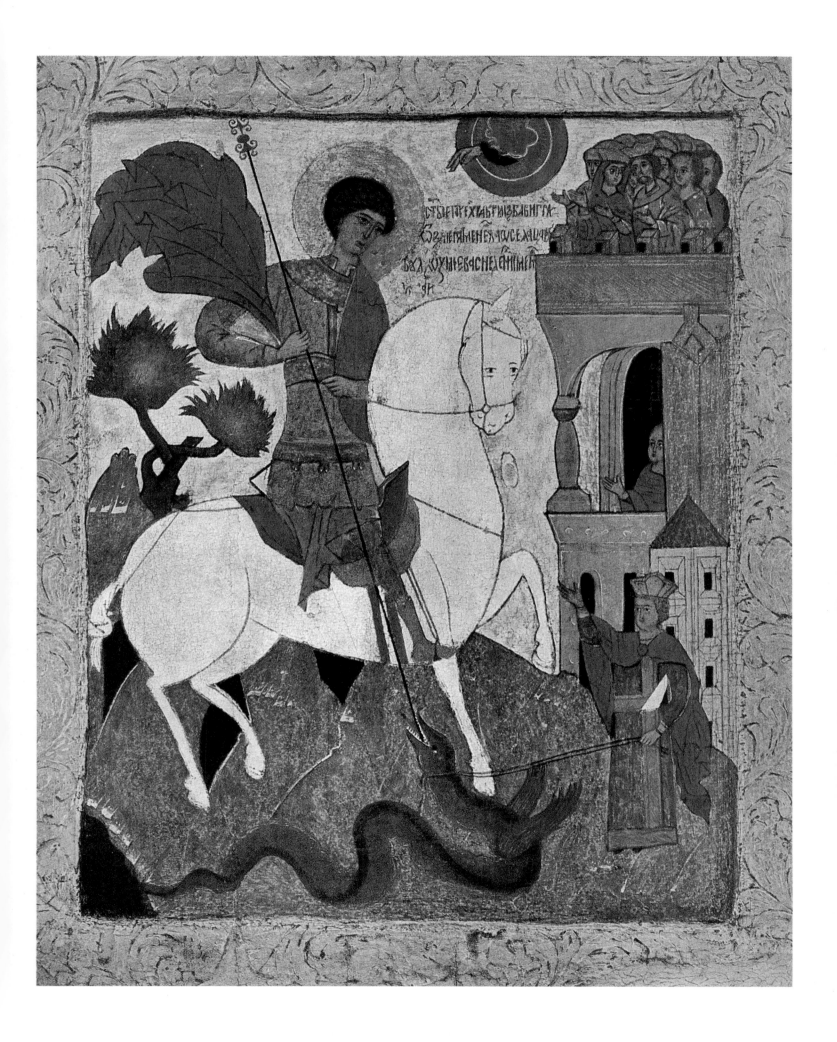

PLATE 54

Icon of St Zosima and St Savatiy

Late sixteenth or early seventeenth century. School of Ustuig, or perhaps the work of a monk in Solovetsk Monastery. Now in the Tretiakov Gallery, Moscow.

The two saints represented on this icon were the founders of the famous Solovetsk Monastery, and the monastery itself, standing on its island in the waters of the White Sea, serves as a background for the figures of the two saints. The monastery is depicted in its entirety as it was at the time of its greatest glory, with the contemporary features of the building, such as its profusion of kokoshnik-shaped gables and onion-shaped domes, its detached belfry and complete chime of bells, carefully delineated. Although the monastery and its island are flattened out to form a pattern, considerable efforts at perspective painting are at the same time to be noted in the actual portrayal of the monastic buildings, but the style of the painting is perhaps no longer strictly iconic, verging instead close to folk art.

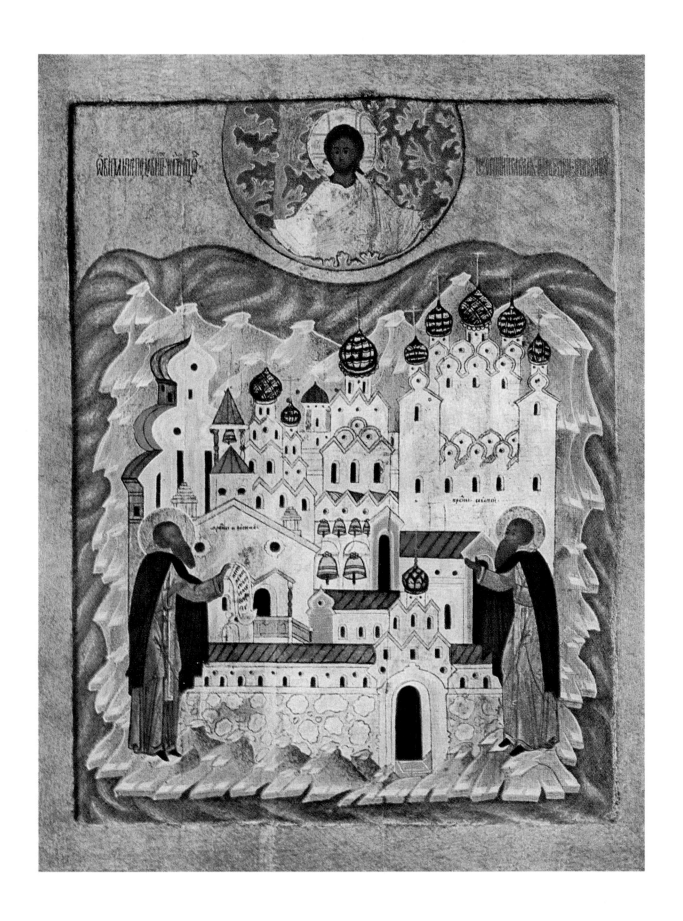

PLATE 55

Icon of St Demetrius and Prince Romanos, both of Uglich

Seventeenth century. School of Moscow. The Russian Museum, Leningrad.

Dmitri, or Demetrius, the son of John the Terrible, was stabbed to death at Uglich in 1591, when he was only eight years old. The deed was performed by Nikita Kachalov and Daniel Batyagovski, but popular opinion imputed it to Boris Godunov, who later succeeded to the throne. The young prince was mourned and venerated, and soon sanctified.

This is a typical icon of the Stroganov school, admirably displaying the great attention paid by artists of this group to minute details of dress as well as to the very small heads, hands and feet with which they endowed their figures. It may well indeed be the work of Procopius Chirin, a leading artist of the group; if not, it must be attributed to a very close follower. The saints wear the royal dress of the period, and attempts at portraiture are apparent in the treatment of their faces. Our Lady of the Sign, enclosed within a circle of cloud, bearing Emmanuel within a circle, looks down on them from above.

Our Lady of the Sign, the Palladium of Novgorod, was derived from the sacred Byzantine painting preserved in the great church of the Blachernae at Constantinople, where the Virgin was depicted Orans, that is to say standing with her hands raised, whilst the Child appeared on a round shield or medallion on her breast. The sacred Novgorodian version protected the city when it was attacked by the Suzdalians in 1169, and small, bust-length renderings were often included on later icons as a sign of the Virgin's special protection.

The icon was originally adorned with a metal cover, because of which the background was intentionally left bare.

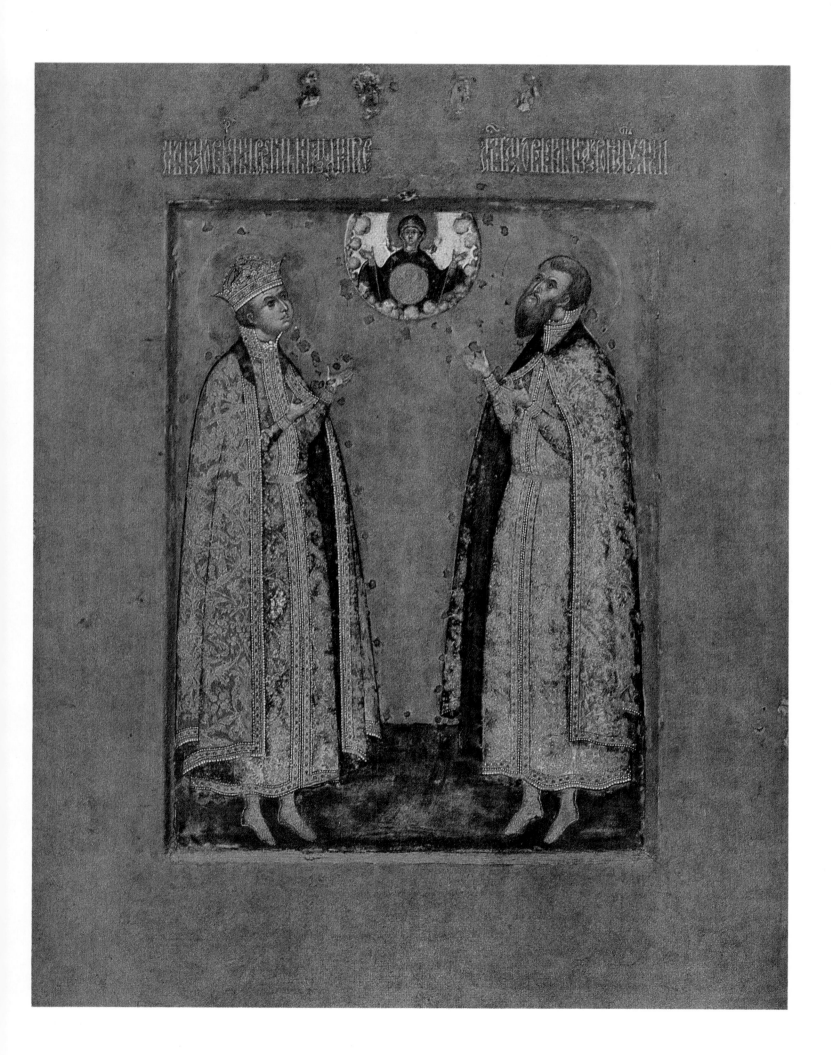

PLATE 56

Icon showing selected saints, signed on the back of the panel by Istom Savin

Circa 1600. Formerly in the Riabushinsky collection.

In the late sixteenth century two members of the Stroganov family established an icon-painting workshop in their country estate at Solviche-godsk, in the district of Perm, hoping thereby to stem the decline which was affecting the religious art of those Russians who had come in contact with the naturalistic art of western Europe. The style which evolved at Solviche-godsk became extremely popular. It is very distinctive and has remained for ever associated with the Stroganovs, whose name it bears, though contemporary artists employed by the tsars in the imperial workshops established in the Palace of Arms in Moscow, also worked in the same manner. Furthermore, the latter were eventually joined in the royal workshops by the best artists of the Stroganov workshop, who continued at the same time to execute commissions for their original patrons, the Stroganovs. The icon illustrated on this plate is by the father of one of the leading artists of this group.

Looking from left to right, the saints shown on this icon are the Martyr Nikita, St Gregory Thaumaturgos (Wonder-worker), the Martyr Maura and the Martyr Eupraxia. Certain members of the Stroganov family had been called after these saints, and it is more than probable that the icon was painted especially for them. Our Lady of the Sign is shown offering them her special protection.

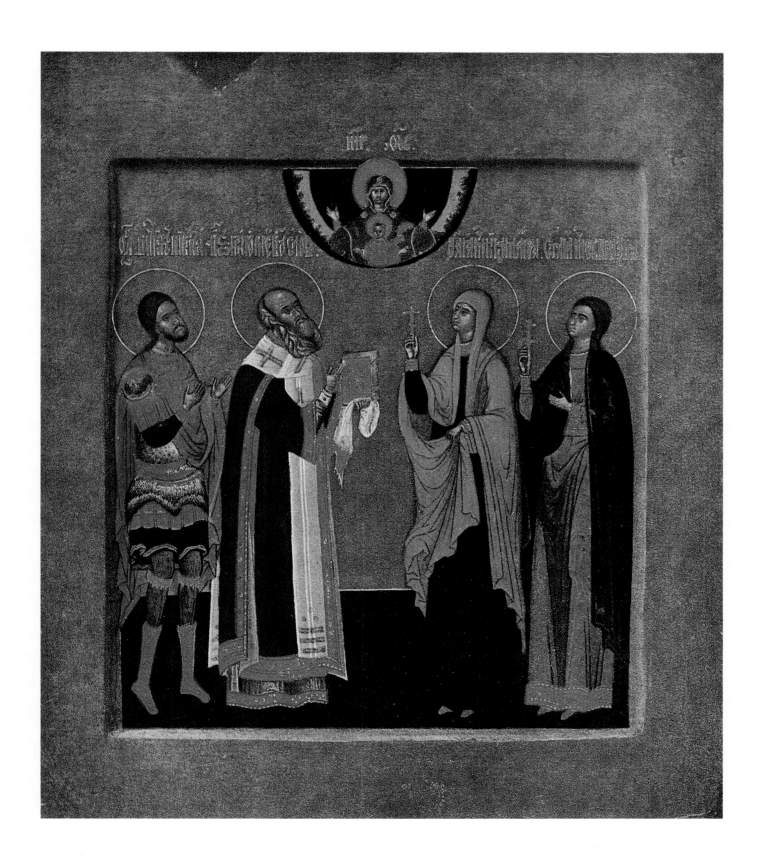

127

PLATE 57

Icon following the Virgin of Vladimir

Ascribed to Procopius Chirin and Nicephorus Savin. Dated 1605. The Russian Museum, Leningrad.

The original icon of the Virgin of Vladimir is a Byzantine work dating from about 1130. In 1131 it was brought to Russia and placed in the cathedral at Vladimir by Prince Andrew Bogolubski, but in 1395 it was moved to Moscow, where it was received with acclamation by the town's inhabitants. The Byzantine painting is of the finest order, and assuredly the loveliest icon to survive to our day. In Russia it was much loved from the start, the humanism with which the Virgin inclines her head to the Child's quickly endearing itself there under the appellation of The Virgin of Tenderness. It served as a constant source of inspiration to artists of every age and school, Andrew Rublev's rendering being among the loveliest. The version illustrated here has lost some of the beauty and much of the emotional power of earlier paintings, yet it remains a work of very high order. Its outlines and white highlights are ascribed to Procopius Chirin and the rest of the work to Nazarius, Istom Savin's younger son.

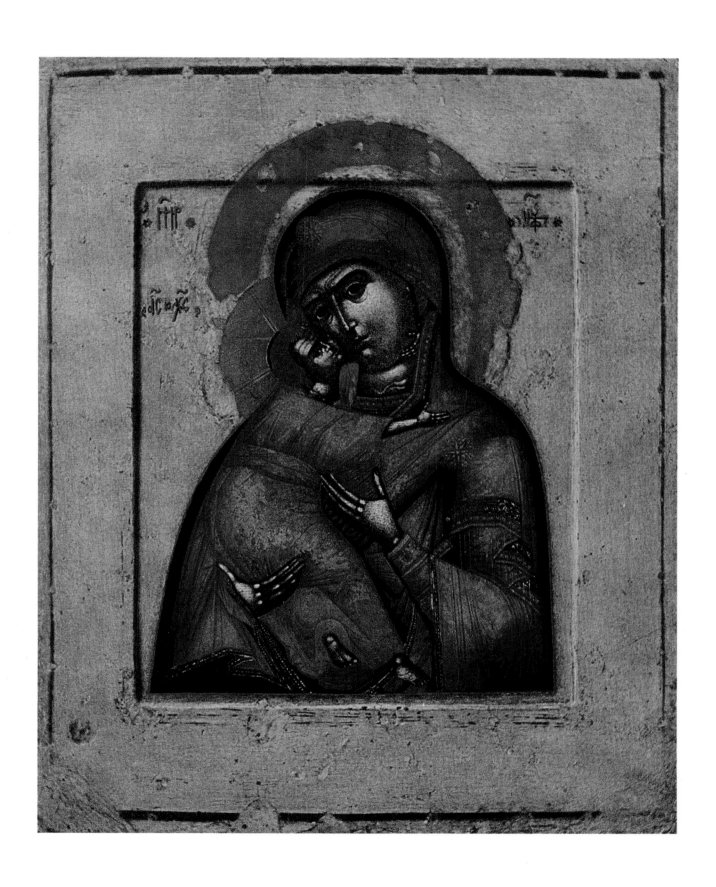

PLATE 58

St John the Forerunner in the Wilderness, by Nicephorus or Nazarius Savin

About 1600. Formerly in the Ostroukhov collection.

This is one of the finest icons of the Stroganov school, displaying to perfection the exquisite painting in gold and the great skill with which numerous minute details are successfully grouped in a very small space. Also peculiar to the style are the small extremities and the tiny, emaciated heads, but the icon has more to commend it, for it may well be regarded as one of the earliest attempts at landscape painting to occur in early Russian art. A wilderness was a thing wholly unimaginable to the Russians, who pictured it as a great tract of virgin land rather than as an expanse of barren soil. The scene is set in just such a rich landscape, showing the Jordan flowing quite naturalistically through a pearl-coloured countryside enlivened by gold-tipped hills, from which many wild animals descend to the river to drink. In the distance a realistic forest belt marks the horizon, its trees besprinkled with gold as if in honour of a special festivity. An archangel appears from the left, leading St John safely through this uninhabited region, and angels benignly watch their progress from above. The icon is by one of Istom Savin's two most talented sons.

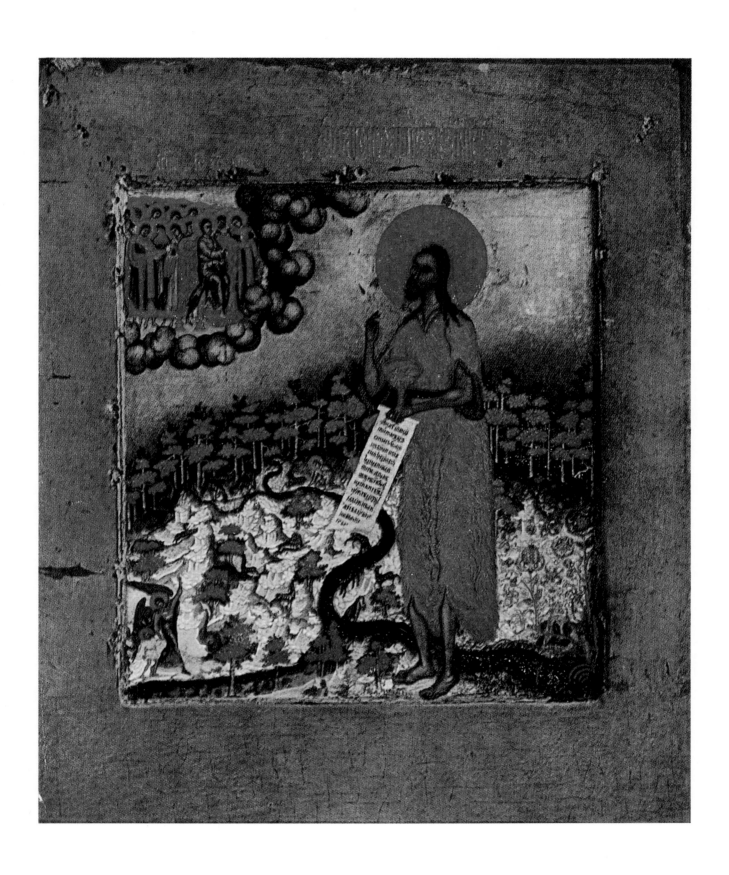

131

PLATE 59

A double-tiered icon signed on the back of the board by Nicephorus Savin

Late sixteenth, early seventeenth century. Stroganov school. Formerly in the Riabushinsky collection.

The Virgin and Child of the Petchersk type appear in the centre of the upper row. On their right stand the archangel Michael, St John the Forerunner and Basil the Great; on their left, the archangel Gabriel and the Prophets John and Gregory; below, from left to right, are St John Chrysostom, St Nicholas, the Bishop Alexius, Simon the Stylite, Saints Cosmas and Damian and the martyr Ezekiel. The icon is quite small, measuring some nine inches by seven, yet, though so many personages appear on it, there is no feeling of crowding. The painter was a brother of Nazarius and a son of Istom Savin, and he worked first for the Stroganovs, then for the tsar as one of the Palace of Arms artists.

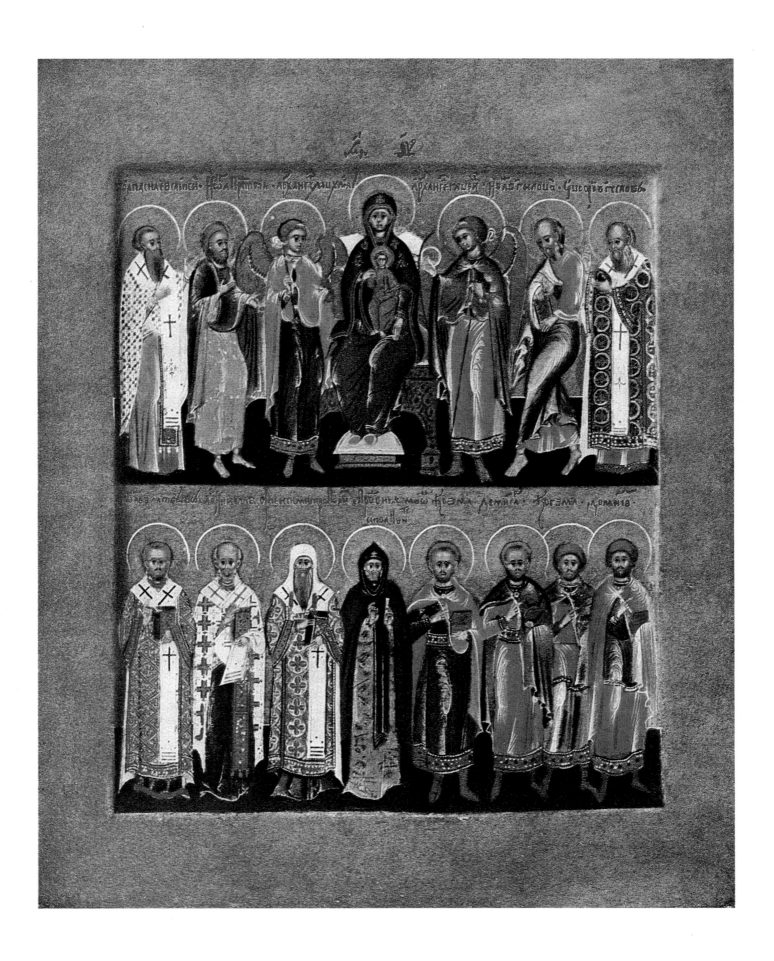

PLATES 60 to 62

A triptych forming the Deesis group by Procopius Chirin and Nicephorus Savin

Early seventeenth century. Stroganov school. Formerly in the Riabushinsky collection, now in the Tretiakov Gallery, Moscow.

The Stroganov artists were particularly fond of painting the Deesis cycle, and there was nothing unusual in Russia in the practice of two or more painters combining to produce a single icon. Procopius Chirin and Nicephorus Savin were particularly fond of working together. Chirin came from Novgorod and was perhaps the foremost artist of his age. He worked for the Stroganovs as well as for the court, and the delicate, miniature style of this icon, with the profuse use of gold both in the background and ornament, and also as hatchings, is no less characteristic of his work than of that of his associates.

PLATE 60

Triptych forming the Deesis Cycle: Left panel

by Procopius Chirin. Stroganov School, Moscow. Early 17th century.

The left wing of the triptych shows the Virgin standing nearest to the central panel, with St Michael and the apostle Peter following her. The icon is signed by Procopius Chirin, most of whose dated works fall between the years 1620 and 1642. Chirin preferred to use a pink ochre for his flesh tints and pale shades of the prevailing colours for his highlights, as well as gold for his hatchings. His colours have the dignity and grandeur of a court art.

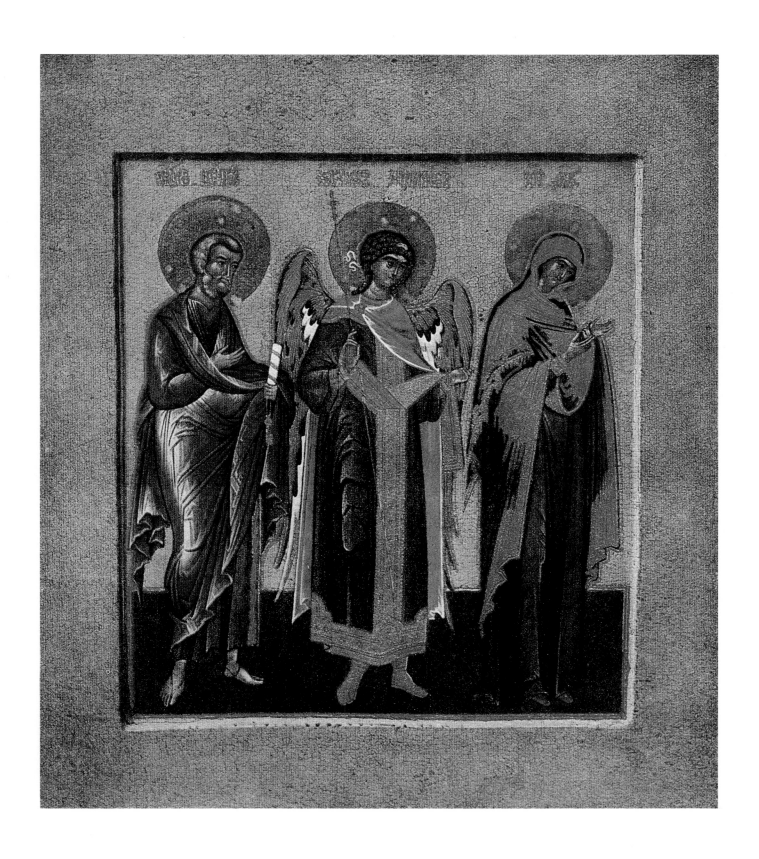

135

PLATE 61

Triptych forming the Deesis Cycle: Centre panel

by Nicephorus Savin.

Centre panel from the preceding triptych. The panel is devoted to a noble representation of the Sabaoth Lord God with Emmanuel the Child, a type known in Russian iconography as 'Paternity'. The icon is signed by Nicephorus Savin. On it the Lord Sabaoth is shown in the heavenly sphere supported by cherubim. A dove, representing the Holy Spirit, hovers above the Child's head, and the emblems of the evangelists occupy the star-shaped projections at each corner. In contrast to Chirin, Savin's highlights are executed in gold and his flesh tints are paler in tone.

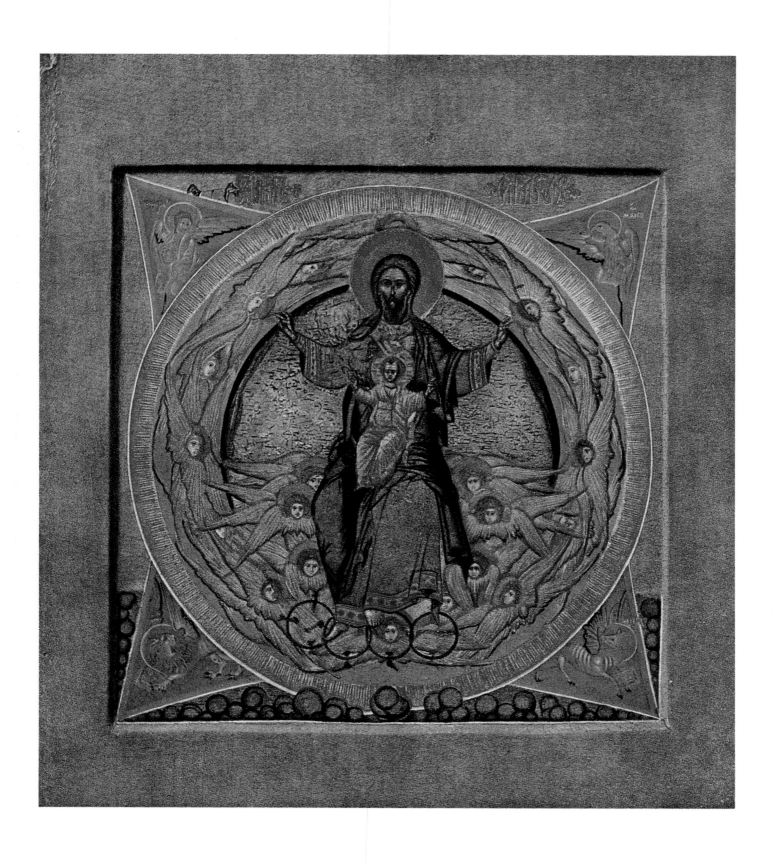

PLATE 62

Triptych forming the Deesis Cycle: Right Panel

by Nicephorus Savin

The third panel of the triptych, showing St John the Baptist, the archangel Gabriel and St Paul, is again the work of Nicephorus Savin. Once again the flesh tints are paler, gold prevails, and touches of white, though absent from the central panel, appear here in a manner which is characteristic of much of this artist's work.

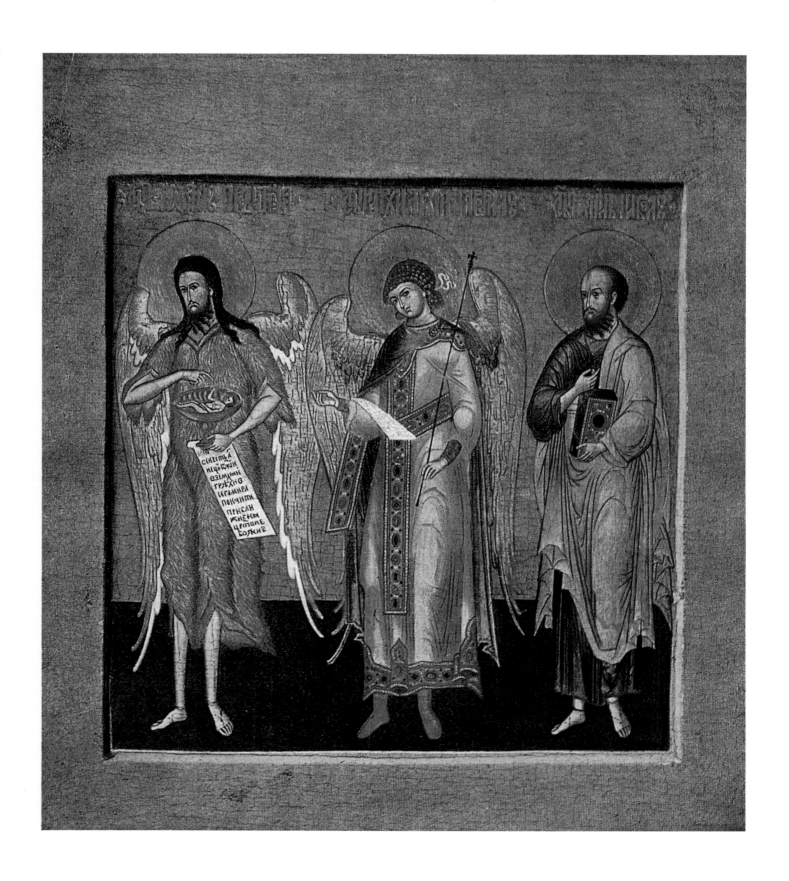

139

PLATE 63

A composite illustration, presenting the Vernicle and also expressing the theme 'Weep not for me, Mother'

Early seventeenth century. The Russian Museum, Leningrad.

The lower scene, which only appeared in Russia in the sixteenth century, can be regarded as the Greek-Orthodox equivalent of the Italian Pietà. It became current in Russia after the Stroganov artists had produced several renderings of it. Here it is combined with the theme of the Vernicle or Holy Mandylion of Edessa, flanked by the patron saints of the people who commissioned the icon. The background was left plain because the icon was intended to have a metalwork cover; there are indeed signs of rubbing which prove that it was at one time adorned in this way. The icon is difficult to place stylistically, for its links with the Novgorodian tradition are too close for it to be by the hand of a Muscovite artist, though the influence of the Stroganov school is also clearly apparent in many small points. The icon may well be the work of a northern artist nurtured on Novgorodian traditions, but acquainted also with contemporary work from the capital.

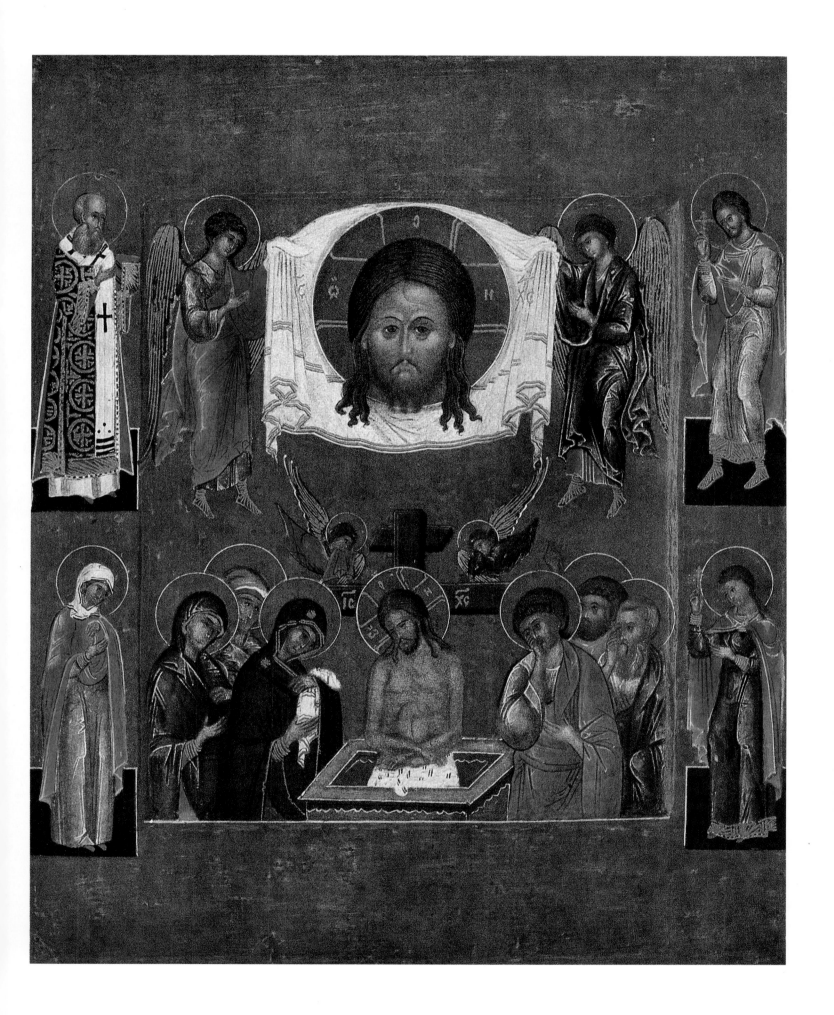

PLATE 64

Icon illustrating the theme 'In Thee rejoiceth'

Seventeenth century. Stroganov school.

The iconography of this theme was evolved in the fifteenth century, the idea for it originating in an anthem which follows a prayer in the Liturgy of St Basil and which opens with the words: 'In Thee rejoiceth, O Gracious One, every creature; the Choir of Angels and all mankind'. Its basic elements consist of a hill topped by a five-domed church with the Virgin seated on a throne placed in front of it, whilst representatives of the celestial and terrestrial worlds are grouped around her.

The icon illustrated here displays the traditional great church of the Holy Mother of God shown against a wooded background of considerable charm. A Choir of Angels surrounds the seated Virgin and Child. Immediately above them is the Lord God Sabaoth, and immediately beneath them stands a magnificent archangel. The crucified Saviour and the mourning figure of the Virgin appear among trees on either side. Saints, fathers of the church, holy men and women, and other venerable figures fill the lower registers.

This elaborate metaphysical theme is magnificently handled by the miniaturist painters of the Stroganov school, the panel acquiring in their hands something of the character of a Byzantine enamel or miniature mosaic; indeed, works of this type come closer in character to the precious objects intended for church treasuries than they do to the easel paintings of the western world and, in direct contrast to the icons of earlier periods, it is in this light that they must be approached, if their full quality is to be savoured.